The
LESBIAN AVENGER
Handbook

A Handy Guide to Homemade Revolution

Homocom Books ▼

Lesbian Avenger Documentary Project

Long before there was marriage equality, or out lesbians on TV, the Lesbian Avengers took to the streets "TO MAKE THE WORLD SAFE FOR BABY DYKES EVERYWHERE." A key to their success? *The Lesbian Avenger Handbook: A Handy Guide to Homemade Revolution.*

Still used today, it contains everything a budding trouble-maker needs to know—from how to hold a meeting to step-by-step instructions on organizing an action, working the media, creating mind-blowing visuals, and keeping protesters safe.

Our new edition largely preserves the original material, but also features new content, including dozens of additional pages of Avenger *Communiqués* reporting on fire-eating demos, fear-defying zaps, and provocative kiss-ins from the sixty chapters worldwide. An essential resource for activists and historians alike! So get busy. Wreak havoc. Avenge.

PRESS FOR THE LESBIAN AVENGERS

"As onlookers pondered the stereotype-defying scene, the demonstrators reveled in their sheer numbers. It was, for once, an unabashed display of lesbian clout."

—Newsweek on the first Dyke March in Washington, D.C.

"They tried to barge into my office, so I closed the door," Ms. Penney said. *"Then they pounded on the door."*

—New York Times

"At times, the [NYC School Board] election seemed to be about Pat Robertson on one side, and the Lesbian Avengers on the other."

—New York Newsday

"Using a combination of in your face activism, erotic hyperbole and jargon-bending 90's wit, the Lesbian Avengers have become the newest wave of queer politics."

—The Gazette

"Guerrilla action works."

—New York Daily News

Cover photo by **Carolina Kroon**

Update handbook design, type by **Lutzka Zivny**

New York Avenger Graphic Designs by **Carrie Moyer**

Original handbook design/type by **Amy Parker**

First Homocom Books Edition
© 2021 Homocom

Revised edition
© 2011 Lesbian Avenger Productions

Original edition
© 1993 The Lesbian Avengers
New York, NY

The Lesbian Avenger Documentary Project
is a project of the Homocom Corporation,
a 501(c)(3) nonprofit.

www.lesbianavengers.com | www.homocom.org

The
LESBIAN AVENGER
Handbook

A Handy Guide to Homemade Revolution

Homocom Books Edition

Edited by
Kelly Cogswell

Additional contributions by
Alexis Danzig, Lisa Amin

Original New York Lesbian Avengers Edition

Text by
Sarah Schulman

Additional text by
Marlene Colburn

**Ron Goldberg, Amy Bauer,
Andrew Miller and Alan Klein**
ZAP/Action Teach-In Outline

Ellen Levy, Phyllis Lutsky, Carrie Moyer, Sue Shaffner

Maxine Wolfe
Checklist and Outline for Actions

Resource
Gene Sharp
The Politics of Nonviolent Action

Edited by
Amy Parker, Ana Simo

Table of Contents

PREFACE IX

INTRODUCTION 1

MEETINGS 3

PLANNING AN ACTION 5

Preliminary List of Tasks for Your Action 8

Graphics/Visuals 9

Identifying Resources 12

Audio: Marching Bands 12

Contact Lists 12

Leafleting and Wheatpasting 13

Networking/Contacts 14

Fundraising 15

Money/Receipts 17

Media 17

Video 19

Marshals 20

Legal Support 23

Police and Permits 24

Attorneys 25

Legal Observers 25

Tips for Demonstrating During a Pandemic 25

Tips for Participating in Demonstrations
When Civil Rights Are Kaput 26

APPENDIX 1: CONFLICT RESOLUTION 29

APPENDIX 2: LOGOS, FORMS, SAMPLE MEDIA LIST 31

APPENDIX 3: NEW YORK AVENGER GRAPHICS 37

APPENDIX 4: COMMUNIQUÉS FROM THE FRONTLINE 47

AN INCOMPLETE HISTORY OF LACROP 69

TIPS FROM *OUT AGAINST THE RIGHT:
AN ORGANIZING HANDBOOK* 74

YOUR AVENGER NOTES 86

PREFACE

Launched in New York City, in 1992, the Lesbian Avengers rejected the earnest picket line and clenched-fist demo for media-savvy, nonviolent direct action, redefining lesbians with every pamphlet, every feat.

We were superheroes arriving "to make the world safe for baby dykes everywhere;" warriors with capes and shields doing a line dance; dykes "Lusting for Power," pushing a giant bed float down Sixth Avenue in New York (with lesbians on it); nationally-ambitious Avengers eating fire in front of a hostile White House; lovers reuniting a statue of Alice B. Toklas with Gertrude Stein, then waltzing in the snow in Bryant Park. And homos who shamelessly chanted, "Ten percent is not enough, recruit, recruit, recruit."

It only took a few years for the Lesbian Avengers to grow into a movement with sixty autonomous chapters worldwide all working for the visibility and survival of lesbians, and all sharing an irreverent direct action aesthetic, eagerly dipping into agitprop and advertising and theater, in ways that still feel ground-breaking today.

Key to our success were the tools we developed to help dykes understand and reproduce the Lesbian Avenger action. One was the 1993 documentary video, Lesbian Avengers Eat Fire Too, *which offered the why, the who, and the what, featuring interviews with Avengers, and sharing actions from our first year.*

Another was this book, The Lesbian Avenger Handbook: A Handy Guide to Homemade Revolution, *which offers step-by-step instructions for everything from how to hold a meeting to how to envision an action and wrangle the press—expertise gleaned from Avengers working in journalism, advertising, art, and theater, as well as long-time activists who honed their skills protesting the Viet Nam war, the abuse of farmworkers, forced sterilization of women of color, and bans on abortion, and who'd already, in many cases, led civil disobedience and direct action.*

We release this new edition of The Lesbian Avenger Handbook *as lesbian rights and liberation face renewed attacks. The bulk of this extraordinary resource is unchanged, though we've cleaned up typos, and acknowledged advances in technology for activists still using it today. We've also added important bonus material, including tips for demonstrating when civil rights are being trampled.*

Also included, An Incomplete History of LACROP *(the Lesbian Avenger Civil Rights Organizing Project), and excerpts from their* Out Against the Right: An Organizing Handbook, *important historical documents offering hard-won insights about dyke organizing and the importance of building community for long-term social change. One important reminder: not everybody thinks alike, or should, even if we share the goals of equality and liberation.*

With dozens of new pages of Avenger newsletters, Communiqués from the Frontlines, *and the inclusion of the Dyke Manifesto, the Handbook has also become a kind of Lesbian Avenger history told in our own words, reminding us of how much we accomplished, and how much is still left to do in this world where lesbophobia, that cocktail of misogyny and homophobia, still reigns supreme.*

So get busy. Wreak havoc. Avenge.

—Kelly Cogswell,
Lesbian Avenger Documentary Project
June 1, 2021

INTRODUCTION

The Lesbian Avengers is a nonviolent direct action group using grassroots activism to fight for lesbian survival and visibility. Our purpose is to identify and promote lesbian issues and perspectives while empowering lesbians to become experienced organizers who can participate in political rebellion. Learning skills and strategizing together are at the core of our existence.

There is a wide spectrum of opinion in the lesbian community about what kinds of strategies to employ. Some people want to be in therapy groups. Some people want to work on electoral and legal reform. As a direct action, activist group, the Lesbian Avengers is not for everybody, nor should it be.

The Avengers' approach is for women who want to be involved in activism, work in community, be creative and public, do shit-work, take responsibility on a regular basis, have their minds blown, change their opinions, and share organizing skills. Other strategies are also valid, but the Avengers' reason for existing is direct action.

The Lesbian Avengers were founded in June 1992 by six experienced political activists. They had a vision for grassroots lesbian activism that would go beyond visibility to the larger goal of sustained movement building. On Gay Pride Day that year, these six handed out 8,000 fluorescent green club cards that said: "Lesbians! Dykes! Gay Women! We want revenge and we want it now." Fifty lesbians came to the first meeting. Since that time, increasing numbers of lesbians have come to Avengers' meetings in the spirit of cooperation, negotiation, and flexibility in order to build a community of skilled political organizers committed to action.

What follows is concrete information on how to organize a direct action group. The more efficient your

frameworks are, the more encouragement there will be for creative, imaginative work. We have left space in the margins throughout this handbook for you to add your own ideas, inspirations, and lists of contacts.

Go girl!

WE WANT REVENGE AND WE WANT IT
NOW!

LESBIANS! DYKES!
GAY WOMEN!

There are many more lesbians in this world than men like George Bush. But cold-blooded liars like him have all the power.

Let's face it:

Government, Media, Entertainment, The Money System, School, Religion, Politeness ... are irrelevant to our lives as dykes. We're wasting our lives being careful. Imagine what your life could be. Aren't you ready to make it happen? <u>WE ARE.</u> If you don't want to take it anymore and are ready to strike, call us now at (718) 499-3802. We'll call you back.
Think about it,

What have you got to lose?

 The Lesbian Avengers

The club card that launched it all.
Text by Sarah Schulman.

MEETINGS

If you want revenge, call a meeting. A meeting is the first step toward a life of retribution and an essential element for organizing Lesbian Avengers. Meetings are a great way to trade info, share skills, and get to know other lesbians. This is the time to report on past and upcoming actions, share news, and sign up for committees. Committees meet outside the general meeting to plan and organize actions and then report back to the whole group for a vote, usually on specific actions and expenditures. A facilitator, armed with the meeting agenda, will keep things moving and focused at your meetings.

Often we begin a meeting by going around the room and having each dyke introduce herself, helping to integrate new people with regular members. Sometimes we end by going around again so each woman can say what tasks and responsibilities she has taken on for the following week. Hopefully, everyone in the room will have taken on some kind of task.

The point of meetings is to get work done in an effective manner, keeping them as short as possible, but also give people time for productive discussion about the politics and creation of the action. Since most of the hammering out of details and brainstorming for creative silliness happens outside the general meeting, in committees, the role of the facilitator is crucial in keeping things focused.

Facilitators volunteer from the membership and usually serve four weeks. We hold a facilitator training every few months and women without experience cannot facilitate without first going through a training. We also ask people facilitating for the first time to invite someone more experienced to sit next to them and help them through their first few weeks.

The facilitator is responsible for conferring with members to set the agenda at each meeting. But more importantly, she is responsible for creating an atmosphere of efficient respect. If discussion at the meeting is vague and wandering, the facilitator must listen closely and try to focus discussion around specific proposals for action. If people come to the meeting with doubts and concerns, the facilitator needs to diffuse the tension and ensure that the Avenger meeting is a place for free exchange of ideas—with purpose. (*See* Appendix 1 *for advice on conflict resolution.*)

People have to be able to offer their perspectives openly without being attacked, and to have space to explore and work through ideas. Our meetings need to be flexible and conducive to creative thought. It is the facilitator's job to keep people pro-active, encourage them to make concrete suggestions, help share alternatives with group input, and encourage people to take responsibility for their ideas. The facilitator must ensure that proposals are presented in ways that build consensus and allow the largest number of Avengers to be involved.

Meetings can begin with a statement of things to keep in mind, such as respect for all voices, the desire for short, productive meetings, and the recommendation to step back if you are someone who talks often, and to step up if you are a person who rarely shares their thoughts in meetings.

The facilitator should set an agenda focused around the most important business—keeping longer things like teach-ins and short announcements until the end. She needs to keep the meetings running smoothly and with focus on the tasks at hand. Usually the discussion should not run longer than ten or fifteen minutes, at which point the facilitator can offer the room the option to wrap up discussion and vote, or to continue the discussion at a deeper level. If she sees that people are repeating each other's ideas, she can ask if anyone has something new to add.

PLANNING AN ACTION

The purpose of any action is to make our specific demands known, win change, and involve as many lesbians as possible in all aspects of organizing to help them build skills.

When Avengers have an idea for an action they can bring a precise, specific proposal to the floor, or they can come to the floor with a vague idea and pass around a sign-up sheet for those interested in developing the project. Those who sign up then meet separately as a committee to develop the idea, outline tasks, and return to the group with a specific proposal. This way the large group discussion will revolve around a concrete proposal creating a framework for a more constructive and satisfying, task-oriented discussion. It also makes it easy for others to plug themselves in.

A proposed action needs to get the approval of the group because it will be undertaken in their name. Once the large picture of an action is approved by the Avengers, the committee gets back to work on specifics. It is in committee that all the brilliant, wacky, specific ideas are worked out. Every action planning committee needs two co-coordinators who are responsible for following up with everyone who took on tasks, and for presenting updates on the action to the floor at each step leading up to, and following, the action.

Co-coordinators need to be sure that their committee addresses the following questions and issues:

CONCEPTS: What is the goal of this action? Are our demands clear? Who are we trying to reach? What is our message?

LOGISTICS: What are the time, date, place, and length of the action? Do these choices make sense given the goals and message of the action? How much physical space

will we have for holding the action? Will the action take place inside or outside? Are there any known obstructions? Where are the entrances and exits? Will we have to contend with security guards or police? Will the action take place on public or private property? How wide is the street for banners and props?

Logistics also includes scouting the location—the actual site of the action—as early in the planning as possible. (For best results, scouts should go to the proposed site of the action at approximately the same day and time as the proposed action. It is not useful to visit a site on a Saturday afternoon for an action planned for a Monday morning during rush hour.)

Further logistical concerns include: How many people will be participating in the action, approximately? Will they be Avengers only? Lesbians only? Is it open to anyone? Is advance outreach/invitation to allies a good idea? Will the action be announced in advance via social media, or is the element of surprise essential to this action? Who will take responsibility for creating a public message on social media? What kinds of props and supplies are needed to get across the message? Signs, banners, educational leaflets? Who will transport them to and from the action?

TACTICS: What type of action are we planning: symbolic, disruption/interference, education? Avoid old, stale tactics at all costs. Picketing and chanting rarely make a bold impression; standing passively and listening to speakers at a static rally is often boring and disempowering. Look for daring, participatory tactics depending on the nature of your action: e.g., a march, a theatrical tableau, a shared public reading of denunciation, etc.[1]

New York Avengers have staged overnight encampments, surprised politicians with daring zaps in the halls of the Plaza Hotel, invaded the offices of SELF magazine,

1 For a list of tactics, see Gene Sharp's 198 Methods of Nonviolent Action. https://www.aeinstein.org/nonviolentaction/198-methods-of-nonviolent-action/.

marched down Fifth Avenue at rush hour with flaming torches, and handed out balloons that said, "Ask about lesbian lives!" to school children in an anti-gay district. The visual design of the action should let people know clearly and quickly who we are and why we are there— the more fabulous, witty and original the better. New York Avengers have used a wide range of visuals, such as fire-eating, a 12-foot shrine, a huge bomb, and a ten-foot plaster statue.

CONTINGENCIES: Actions should be as detailed and well-planned as possible so everyone knows why we are there and feels involved. But, since there is no way we can know everything in advance, we also have to be ready to make decisions on the spot in a quick and supportive way. Considering the following questions in advance can help you act instantly when necessary during the course of an action:

- What if we can't get to the spot we planned the action for? Is there a Plan B?
- What if the group that shows up is smaller/larger than anticipated?
- What's the plan if there's bad weather?
- Are we prepared to deal with police interference, and who will handle that?
- Is this an action for which people should be prepared to risk arrest, or are we prepared to make decisions about arrest on the spot?
- Will we announce a public start or end time in advance to ensure maximum attendance, and if not, what is our decision-making mechanism for starting and ending? We don't want our action to just fizzle out.
- Is there a way to thank people for coming and invite them to the next action or Avengers' meeting?

PRELIMINARY LIST OF TASKS FOR YOUR ACTION

Once the general shape and look of the action have been planned, committee members can begin working on specific tasks. The two co-coordinators are responsible for follow-up with each member of the committee to make sure their responsibilities are carried out on schedule. (See Final Action Checklist, Appendix 2.)

- Graphics: leaflets/flyers, posters, banners, signs, props
- Sound: marching band, rattles, whistles
- Leaflet reproduction (copying)
- Emailing/messaging
- Social media promo
- Wheatpasting
- Outreach: contacting other groups/lesbians
- Fundraising
- Media
- Video or streaming team
- Fact sheet (translation if necessary) to give out at action and post online
- Marshals
- Legal support
- Attorneys
- Legal observers
- Health and safety

Remember—the point is to involve as many Avengers as possible in the organizing. One easy way to do this is if each committee member responsible for a task always comes to the large group with a sign-up sheet (ie., Sign up here to distribute flyers at the lesbian bars," "Sign up here to learn baton twirling for the action," etc.). Committee members then contact each person on the sheet to remind them of the time and place where the

training or work will be done. The more organized the co-coordinators are, the easier it will be for people to plug themselves in and participate.

GRAPHICS/VISUALS

If you've ever spray-painted anti-hate slogans around town, you know how good it feels to vandalize for a good cause. But there is more to direct action than catharsis. In our post-modern age, media coverage is the message. Direct action is about getting attention, so don't be shy. The media loves photo ops, so give them something to look at—dykes in debutante gowns, slanderous slogans on banners and placards, Sapphic serenades, flaming shrines!

Once you've decided on a target—e.g., an openly homophobic lawyer, a Cardinal, a wayward pol—plan a dramatic action. It's important to have a clear message, so keep it simple. The details of your position can be spelled out in the leaflet or fact sheet that you distribute at the action and post online, which should clearly explain why you're staging the action and give facts to back up your position.

The visual design of our actions has always been a crucial part of Avenger work. In general we try to make each action look different from our previous events and have a style and presentation that has never been used by anyone before. Props (floats, shrines, burning torches, paper-mâché bombs, plaster statues... whatever!) play a huge part in this. Graphics need to be bold, eye-catching, meaningful, and visually exciting. The more creative, imaginative, and individual our actions look, the more inspiring and fun they will be.

The design of an action usually begins with the preliminary flyer announcing the event to the community. Innovative design and contemporary, clever

graphics—right down to the color of the paper—are important ways to convey to the viewer how fearless, open, and new our approach is. To date, our invitational leaflets have been one of the Avengers' strongest calling cards. (*See* Appendix 3 *for example graphics created by the NYC Avengers.*)

Usually the flyer features a slogan or phrase that will be a constant theme throughout the action. We try to never use a cliché or tired old rhetoric. Instead we've been able to come up with a wide range of eye-catching titles. When we built a shrine to Hattie Mae Cohens and Brian Mock, two gay people murdered by a firebomb in Salem, Oregon, our demo posters said, "DON'T LET THEM REST IN PEACE." When we dogged the mayor of Denver for 48 hours, the signs said, "BOYCOTT THE HATE STATE." When we held our New Year's Eve party, the poster featured a picture of 70s Blaxploitation film star, Pam Grier, in hot pants holding a rifle. The poster advertised "ACTIVIST A-GO-GO."

Our Valentine's Day action honoring Gertrude Stein and Alice Toklas celebrated "POLITICALLY INCORRECT DOMESTIC BLISS." Our demo banners favoring the New York City Department of Education's multicultural curriculum said, "LIGHTEN UP! TEACH ABOUT LESBIAN LIVES." The banners for the torchlight parade down Fifth Avenue said, "WAKE UP! IT'S HAPPENING HERE," and for the March on Washington said, "LESBIAN AVENGERS: OUT FOR POWER." Whether the theme is whimsical, outrageous, or angry, our slogans have been clear, clever and strong.

Don't forget to put contact information for your group on all your flyers, posters and other materials, so potential Avengers can find you—unless you purposefully don't want the public or the police to know who is distributing the information. Remember to include the bomb logo and the tag, "The Lesbian Avengers is a direct action group focused on issues vital to lesbian survival and visibility." Get the word out.

From the very beginning of an action's planning stages, the working group needs to meet with a designer to conceptualize what the action's visuals will look like. It is important to recognize that good graphics—plastered all over the place, far enough in advance—can make or break your action. With this in mind, the entire graphics/promotion process needs to begin AT LEAST 3-4 weeks BEFORE the date of the action. At that time, the working group and designer will begin to conceptualize what the poster will look like. In addition, the working group should provide the designer with the following:

- A snappy headline
- A paragraph of copy describing why the Avengers are doing the action
- Whatever art or photograph the working group has chosen or would like the designer to consider when coming up with visuals
- The action particulars: date, time, place, directions if necessary
- How and where your flyers will be distributed (wheatpasted, handed out at bars, posted online, etc.) because that may necessitate creating the flyer in several sizes

The standard sizes appropriate for wheatpasting are 8.5" x 11" or 11" x 17". The "club card" quarter-sheet size (4.25" x 5.5") is best for pressing into women's hands at bars, or at Pride or other events like marches.

ALLOW AT LEAST ONE WEEK FOR COMPLETION OF GRAPHICS AND UP TO AN ADDITIONAL WEEK FOR REPRODUCTION.

IDENTIFYING RESOURCES

Lots of lesbians have resources that they are willing to share with the Avengers, even if they don't want to come to meetings or help organize actions. Someone may be willing to do legal support for an action, design flyers or websites, make videos, or just wheatpaste.

Find out who has access to free copying at their offices. Give them advance warning and assistance transporting the guerrilla copies.

AUDIO: MARCHING BANDS

Chants sometimes aren't enough. A marching band, drum corps, rhythm section, etc., can really make an action lively. Musicians in the group can get together with their instruments or make their own, or even just bring pots and pans. Be sure to notify or invite musicians well in advance of any action you may plan.

CONTACT LISTS

In order to involve as many dykes as possible, Avengers have to be cooperative, organized, and, most importantly, know how to use contact lists and social media as organizing tools. At every Avenger meeting we pass around a list for names, phone numbers, and email addresses. New members are invited to add their names and contact info to the list. An updated activist list is presented every week. This contact information is to be used only for Avenger business.

This list represents our general activist pool. Whenever we have a planned action, we try to contact everyone on the list. Whenever we need people to leaflet, wheatpaste, work on a dance, or build props, we contact the list.

At every dance or other public event we hold, we are sure to have a sign-up sheet for supporters at the door. This is our constituent base. They receive notices for all actions and events. Since these people aren't regulars at meetings, we wouldn't call them for help with preparing for an action. But when it comes to filling the streets —or our bank accounts—they are among the ones we count on the most. Likewise for contacts from websites and social media sites. Designate a Contact List Diva responsible for keeping your lists of activists and supporters current, and getting the word out every time you have an action or need to fundraise.

LEAFLETING AND WHEATPASTING

Flyers make for cheap and easy outreach: leave them in church pews, gym lockers, bars and bookstores, staple them to your dog before letting her out of the house, wheatpaste them everywhere—on lampposts and bus stops.

Wheatpasting is the activist term for adhering flat art onto outdoor surfaces so that the unsuspecting community becomes a captive audience. As long as we have bodies, a real-world presence is still key. Here are the supplies you will need:

- A sign-up sheet of willing and able Avengers who know where to meet and when
- Wheatpaste—wallpaper paste in powdered form, usually comes in a one-pound bag
- Wallpaper brush—with a wooden handle and straw bristles works great
- Plastic bucket—one gallon or larger
- Clothes you don't mind getting messy
- Rubber gloves—optional
- Yellow night-vision glasses (protects eyes and creates fashion statements)—very optional

(All of the above supplies—except night vision glasses—are available at hardware stores.)

Mix the wheatpaste according to the instructions on the package. Mixing slowly using hot water prevents wheatpaste from becoming lumpy, but if you're on the run, buy a bottle of water from a deli, or bring some in a thermos.

We recommend three people for an effective, speedy wheatpasting team. One to apply paste, one to slap down the flyer on top of it, and one to stand lookout. The *paster* coats the surface where the flyer will be placed. The *slapper* slaps down the flyer on the pasty place, and then the *paster* puts a finishing top coat on the flyer. The *lookout* checks casually for any police and large homophobic people. If she sees any, she informs the rest of the team immediately—whistling is great if it's loud—and everyone should know to leave the area.

The best sites for wheatpasting are lampposts, mailboxes, deserted storefronts, construction sites and the sides of dumpsters. Avoid brick walls or other uneven surfaces when possible. Putting up a large block of posters in one place creates a more arresting visual message. Yes, wheatpasting is technically illegal, but, at least in New York City, the law is rarely enforced. Still, it's best to keep your activities on vampire standard time for less interruption and maximum success.

Those outside New York City should research their local laws and penalties, and inform participants, so everyone knows the risks.

NETWORKING/CONTACTS

Before each action, we try to make personal contact with as many lesbian groups and lesbians in LGBT or related groups as possible to let them know what we're doing. Avengers who participate in other organizing groups

can volunteer to maintain contact with these groups on a regular basis. This is a great job for coalition- and cooperation-oriented people.

FUNDRAISING

As Avengers, we decided from the beginning that we did not want to apply to foundations for grant funding, and instead would raise our money by drawing on our support in the community. We throw wild, creative, insane parties on a regular basis with really creative posters—usually following a great action. The better, more successful, our action, the more people from the community attend to support us. Most of us are broke, so our events never cost more than we can pay. On New Year's Eve (1992) we charged $5 admission, 25¢ for coat check and $2 for beer—and took in $5,000.

We usually come up with a fun theme for our parties, make thorough preparations, have great music and also provide a media room with videos and visuals. Parties aren't merely fun, they're an essential organizing tool. We see how well the community likes us, have a chance to let our supporters know about the actions we're up to, invite new people to our weekly meetings, and sign up lesbians for our constituent mailing lists.

A good party takes about a month to organize. It requires at least two co-coordinators. First, coordinators should make a list of specific tasks and bring sign-up sheets to the general meeting so that the most Avengers possible are involved in the planning and creation of the event. The co-coordinators should make sure they have recruited dykes to handle the following tasks:

VENUE: Locate an unusual space, not familiar to your audience but large enough for dancing, lounging, hanging out, entertainment, etc.

PUBLICITY: Generate an eye-catching flyer early enough to claim that day—try to avoid conflicts with other large community events. (E)mail the flyer to your mailing list. Distribute huge numbers of them early. Let newsletters, newspapers, radio shows, blogs, social media followers etc., know in advance. Wheatpaste extensively.

MUSIC: Music is the key to a great party. If no live DJ will volunteer their time, then find someone with diverse and extensive musical knowledge. A good sound system is absolutely essential.

DOOR AND SECURITY: Two dykes are needed to post themselves at the door to collect money and to be sure that every person who enters signs up on the contact list. Cash should be picked up regularly and stored in a safe place—not at the door! A few Avengers should stay on alert to help out with any security problems that might arise.

FOOD AND DRINK: Locate the nearest all-night deli for extra ice and beer. Provide some non-alcoholic beverages as well. Large plastic garbage cans and bags are best for ice control.

SET-UP/CLEAN-UP: You will need to schedule shifts to handle set-up, decorations and clean-up. Sign people up to work at different times throughout the party to clear up bottles, etc. Be sure you have plenty of toilet paper and towels on hand.

MEDIA ROOM: Two Avengers can take charge of displaying fabulous video and propaganda devices.

SPECIAL EVENTS: Go-go girls, kissing booths, tarot cards, etc.—whatever pops into your imagination. In addition to throwing parties and other fundraising events, we pass around an envelope labeled "ACTIONS" at every meeting and ask each person to throw in an extra dollar or two. We sell t-shirts, buttons, and sometimes videos—which are also organizing tools, but we don't want to get too bogged down in the merchandising business.

Avengers and friends can also throw private parties to celebrate birthdays or other occasions and ask guests to make a donation to the Avengers instead of bringing presents.

MONEY/RECEIPTS

If you're planning a big action or event, it's advisable to make one person affiliated with that action responsible for all expenses/receipts. Avengers should be sure to keep receipts for all their expenses for accountability to the group because our rule is that we absolutely cannot reimburse anyone without a receipt.

We keep legitimate records of expenses so that the IRS has no reason to harass us at tax time. Write your name and a simple note about what the receipt was for on each one: for example, "Supplies for November 19 action." You don't have to go into excruciating detail about the expenses because we only use general categories like Copies, Supplies, Postage, Transportation. Put all your receipts in an envelope, or staple them together, and bring them to the next meeting. Please don't expect to get an immediate refund. It will take a few meetings to sort out.

MEDIA

STANDARD MEDIA: Good, efficient media work is essential to any activist organization. The first thing you need to do is amass a list of media contacts: journalists, editors, bloggers, influencers. Go through all the daily papers and weekly publications in your area, and online, and identify people who write stories with lesbian or gay themes or people behind the scenes and in other departments who might be either openly or discreetly LGBT and sympathetic to Avenger causes.

Call every local radio and TV station and ask them directly for the names of people on staff (not only news staff) who are particularly interested in LGBT coverage. Make personal contact with anyone in any media outlet who is openly lesbian.

Four days before your action send your press release to your entire media list and then spend the next few days making follow-up phone calls encouraging the press to attend your event. Always use the same press release format that includes the Lesbian Avenger bomb logo, our tag line—*The LESBIAN AVENGERS is a direct action group focused on issues vital to lesbian survival and visibility*—as well as the day, time, and place of your general meeting. Also include contact information including website, email, phone, etc., so that interested dykes can find more information.

At the action itself, have a few Avengers who are prepared to speak to every member of the press and get their names and contact info. That way you know who has responded, who to add to your list, and those you can call afterwards for more follow-up. Personal contact is the best way to get coverage.

TRANSLATION: Fact sheets and press releases to the Spanish language press should be translated into Spanish. Ditto for other languages. Translators need enough advance time to do a good job and get their draft to the designer without creating a bottleneck.

LGBT PRESS: The LGBT press ranges from glossy national magazines to xeroxed bar rags and blogs. There are countless newsletters, newspapers, websites, and online resources around the country. Sending press releases, communiqués, links, and clippings to the LGBT media is another good way of encouraging the spirit of activism among lesbians and inspiring them to establish new Avenger chapters. It also provides crucial coverage of

our issues, something which we cannot expect from the mainstream media. Of course it is particularly important to emphasize media focused specifically on lesbians.

WEBSITES & SOCIAL MEDIA: Traditional media still has the largest reach, but we are no longer dependent on it to get our message out. Create a presence online. A Facebook page, and Twitter and Instagram accounts are really useful for capturing the range of social media users. Post all press releases, carefully written, to your own website or other networking sites, along with documentation of actions like photos and video. Make friends with LGBT influencers. Tweet and retweet the news. Post links. Promote your content shamelessly.

VIDEO

Every single action should be covered by an Avenger video team or social media-savvy individual. Livestream using cell phones to upload video while the action is still going on, but if you also shoot with standard digital cameras that can capture broadcast-quality video, your footage will go further. This way, even if you don't get television coverage at the time of your action, you can provide TV stations with your own footage after the fact. You should also post edited videos online, and saturate local (or regional) public-access cable channels.

Make sure your videos are easy to find online, dedicating a page or channel to visuals of your events. These videos are not just a record for the press, but are excellent organizing tools for recruiting new activists. When the Avenger phenomenon was brand new, video was key to sharing the type of actions, visuals, and the spirit that defined us. Cell phones/video should also be used to document any confrontations with police.

MARSHALS

Actions need marshals—a group of trained, designated Avengers who take responsibility for small decisions such as communicating information to action-attendees and passers-by, as well as big decisions, like when to move from the sidewalk into the street, or when to sit down in traffic if risking arrest, etc. Marshals serve as a wall between demonstrators and the police and are also the people who block traffic during a march as the procession moves by peacefully.

Marshals need to be trained *before* an action, learning the first-amendment (legal) rights that enable everyone to organize and participate in demonstrations without first acquiring permits, developing a method of communication and cooperation with each other, and deciding who will intervene with hassles when they arise (police, hecklers, trolls, etc.). Usually Avenger marshals are identifiable by brightly colored armbands which are distributed to marshals when they show up at the action and collected for re-use after the action.

Often, existing direct action groups are willing to do free marshal trainings. During the Trump administration, the group Rise and Resist were even willing to do road trips to offer day-long training sessions. In New York City, activists have consistently relied on the War Resister's League and some Quaker groups.

Avengers outside New York need to research their own civil rights, and inform members about their own rights to free speech and assembly (or lack of them). Transparency is important. You build trust with participants by always being honest about risks.

The following tips for marshals are provided as a reference and cannot replace a formal marshal training.

1. The role of the police at an action

- Protect property from damage
- Keep you from making a commotion

2. The role of marshals

- Provide information
- Facilitate the action as it was planned by the Avengers
- Deal with police, hecklers, bystanders

3. What's legal (in New York)?

- Moving picket with signs and chanting on a public sidewalk
- Marching on sidewalk with signs and chanting
- Handing out leaflets, club cards (without either blocking pedestrians or vehicle traffic)

4. What you technically need a permit for (in New York, though the New York Avengers have done these things without permits)

- Use of electronic sound device
- Marching in the street/blocking or stopping traffic

5. What do marshals do on a picket?

- Keep people moving
- Lead chants
- Watch the perimeter for danger or trouble-makers
- Intervene and de-escalate nonviolently when Avengers get hassled
- If civil disobedience occurs, show the limits of legal versus illegal space

6. What do marshals do on a march

- Lead the march at a very, very slow pace; the front of the march is usually designated by a front banner
- Block traffic at intersection (holding hands, facing the drivers in cars)
- Watch the perimeter, being aware of pedestrians and hecklers
- Bring up the rear, create a buffer between any police following the march and demonstrators
- Make sure no one gets left behind; send marshals up to the front to tell the front of the march to slow down (again!)

7. What marshals *don't* do

- Don't do the police's job
- Don't panic, ever

8. Dealing with problems

- Police: Bluff and Stall, Stop and Sit
- Tell them that whatever you are doing is legal
- Ask what law they think you're breaking and why they think you're breaking it
- Ask to see their superior officer; send them away to confer with their superior officer
- Know your rights under the first amendment— and keep insisting on your right to protest peacefully
- NEVER touch a police officer
- Heckler: face trouble, isolate and converse if possible
- Violence: isolate, separate, call attention
- Medical emergency: get police, have another marshal stay with injured party

LEGAL SUPPORT

A coordinated support effort is necessary when there is the possibility or probability of arrest, and especially when your action plan involves deliberately risking arrest.

Support's role is to track the arrestees through the police system and wait for them to be released, to ensure that people are released and know what to do next. Support people take on the responsibility to remain outside wherever arrestees are being held until the last person arrested at the action has been released. For this reason, it's essential to have Support teams made up of several people (3–6 or more!) who can spell each other and take over for each other if any arrestees are held overnight. In short, be prepared to work in shifts. It is essential for those who were arrested to know that they have the group's support and will be met by a friendly face when they are released.

Before the action, Support dykes collect support sheets (See *Appendix 2*) filled out in duplicate. One copy stays with the support coordinator on-site, and, if possible, one copy should be kept off-site in case the Support Coordinator gets arrested by mistake.

During the action, Support people should do everything possible to avoid getting arrested. Support should make a list of each person's name, first and last, as they are being arrested. If you don't recognize the person being arrested, ask them to shout out their name as they are being arrested. Any police violence should be videoed, and Support should try to get the badge numbers of the offending officer. Videoing should be done discreetly: you don't want your phone or camera seized, and if you film an arrest, it is possible for your video to be used against the arrestee. Politely ask the officers driving the police vehicles which precinct(s) or holding places the arrestees are being taken to. Once the arrestees are

driven off, go meet them at the precinct or other holding place. When the police vehicles arrive, call out and try to let the arrestees know that you are there for them.

Support takes turns waiting at the precinct or holding place until the last person is released. Check off names against the lists made at the time of the arrests as arrestees are released, and make a note of each arrestee's email address; take a photograph of the person's Desk Appearance Ticket or Violation to note when arrestees must return for their arraignment in court. Get as much information as you can from released arrestees about the conditions inside the precinct jail (i.e., Who is left inside? Are people being treated okay? Is anyone inside being unfairly hassled for any reason?). Once all arrestees have been released, contact everyone to coordinate an arrestees' strategy meeting before the court date and arrange for an attorney to represent the arrestees.

POLICE AND PERMITS

Under the first amendment in the United States, permits are not needed to protest peacefully. In general, Lesbian Avengers do not contact or negotiate with the police in advance, or ask for permission to do actions. Permits may be needed to hold a demonstration in a local public park, or to have a sound system or close a street for a rally—which is why we avoid most of these types of demonstrations. Of course, special circumstances may require changing this approach. All is subject to discussion in the group.

As always, local requirements vary. And basic civil rights vary from country to country. Make sure you know yours!

ATTORNEYS

Recruit supportive lawyers to attend your action as far in advance as possible. The local LGBT lawyers association or other direct action groups are good places to connect with attorneys who will be willing to represent you, if necessary. If possible, arrange for a friendly lawyer to speak to the group—preferably at a pre-action meeting—so all Avengers participating in the action can have a clear understanding of their legal rights going into the event.

Especially if your action involves deliberately and nonviolently risking arrest, please attend a Civil Disobedience or Nonviolent Direct Action training.

LEGAL OBSERVERS

We usually need at least two legal observers for an action. Legal observers are neutral, and are expected to be prepared to give statements in court about people's actions at a protest.

Before the action begins, make sure you know the names and faces of the attorneys and legal support dykes. Bring paper and pens or pencils to the action and keep notes on the activities of the police throughout the action. If the attorney(s) or police liaison negotiate with the police, at least one legal observer should take notes on what is said.

TIPS FOR DEMONSTRATING DURING A PANDEMIC

- Wear a mask or face covering
- Wear goggles to prevent transmission, but also injury, especially if you anticipate rubber bullets or tear gas

- Bring water. You need to stay hydrated. (Water is also good for washing tear gas out of your eyes)

- Use hand sanitizer frequently

- Consider using signs, drums, or similar noise-makers to get your message across. Chanting and singing expel droplets with a lot of force

- Stick with a small group of buddies to keep your unknown contacts low, and, if possible...

- Practice physical distancing. Try to stay 6 feet (2 meters) away from other people or groups

- Acknowledge the risk. Demonstrations are unpredictable. Peaceful marches may become violent. With the violence instigated either by frustrated marchers, outside instigators, or police. It is almost impossible to maintain safe distancing during the chaotic aftermath. If you should be arrested, expect to be jammed into small spaces with other demonstrators. Cops might also take away your mask

TIPS FOR PARTICIPATING IN DEMOS WHEN CIVIL RIGHTS ARE KAPUT

Demonstrating is more important than ever when civil rights are under attack. It is also more dangerous. Here are tips for harm reduction in mass protests when civil liberties are non-existent or being ignored. The underlying idea is that we hope for the best, but prepare for the worst. Peaceful demonstrations may become violent for a number of reasons. Arrest is always a possibility. We need to be ready for it all.

Here are a list of sensible precautions that you can take:

- Wear goggles to prevent injury. DO NOT WEAR CONTACT LENSES

- Wear sensible shoes. You don't want to be wearing open-toed sandals when a crowd panics and starts to push and shove

- Carry 2 bottles of water (one for drinking, one for washing tear gas out of eyes) + hand sanitizer + bandages
- Bring snacks

ABOVE ALL, PREPARE TO BE ARRESTED

- Disable your cell phone's Face/Touch ID functions. Better yet, don't bring it, or bring a burner phone
- Expect cops to seize your possessions, so DON'T BRING ANYTHING you'd be sad to lose, or that will get you arrested for other reasons, including illegal party supplies or weapons
- Bring your medication. Sometimes cops let you keep it, but sometimes not. Prepare for both eventualities
- Carry photo identification. It will take a lot longer to get out of jail without it
- Do not expect to be able to make a phone call
- Make sure someone outside the march knows you are participating, and arrange for a check-in time, so they can start looking for you if you don't check-in
- Make sure your contact and demo buddies know if you have medical issues
- If possible, go with a small affinity group so that you can look out for each other. If you all get arrested, and someone is hurt or in trouble, you can advocate for them. The one who is released first can report back for the others and advocate if need be. If some don't get arrested, they can try to track the others through the system and advocate for them

Once again:

HOPE FOR THE BEST, PREPARE FOR THE WORST

Appendix 1:
Conflict Resolution

Since the beginning of the Avengers, we have found that certain organizing ideas help us keep our work proactive, gratifying and successful. One outstanding revelation has been to stay away from abstract theoretical discussions. It is easy to create false polarities when there is nothing concrete on the table, but when our political discussion revolves around the creation and purpose of an action, it is much easier to come to agreement, share specific insights, and focus on the skills and tasks we need to accomplish.

Another idea that has surfaced in our work is to encourage each Avenger to take responsibility for her own suggestions—in other words, to be willing to make them happen. This way, "Someone should..." becomes, "I will" or "Who will do this with me?"

Because lesbians have been so excluded from power many of us have developed a negative stance where the only influence we have is to say "no." The Avengers is a place where lesbians can have their ideas realized, where we can each have an impact. A crucial part of that process is learning how to propose alternative solutions instead of just offering critiques. So, if you disagree with the proposal on the floor, instead of just tearing it apart, propose another way of realizing the goal.

If an issue on the floor is contentious and only has the approval of a small majority, instead of proceeding based on a direct vote that creates winners and losers, we try to enter into a phase of negotiated compromise to reach consensus. Great facilitation is useful here! Facilitators need to remember to be as neutral as possible. During this period, every individual must be willing to be flexible and open until we find a solution that most Avengers

are comfortable going forward with. This commitment to negotiation overrides factions and closed analysis, and honors our diverse perspectives.

To focus on the issues at hand rather than either on the numbers or strength of persuasiveness of presentation of individuals on either side, we can alternate *for* and *against* speakers. This way, both sides will have equal representation and the issues will have a chance to emerge. Under these circumstances, we each try to refrain from speaking unless we genuinely have something new to add to the discussion. We also try, despite the passion of our positions, to treat other Avengers as respectfully as possible, focusing our energy on the issue and not on people.

We have also found it productive to take a non-binding preliminary or straw vote. If that first vote is severely divided (whether in a positive or negative direction) we can, before taking a final vote, further attempt to come up with a constructive alternative which addresses the issues where disagreement exists.

If a particularly divisive discussion is taking place at the end of the meeting when everyone is exhausted, we can always vote to table the discussion to the beginning of the next meeting. In that way, we can consider an issue seriously with fresh eyes, rather than reaching a quick agreement just because we want to get the discussion over with.

Either the facilitator and/or the members can decide/request that any of the above methods of conflict resolution be implemented. Of course, if, after all parties negotiate in good faith, we still cannot come up with a solution, a majority vote can be used to determine the final outcome.

Appendix 2:
Logos, Forms, Sample Press List

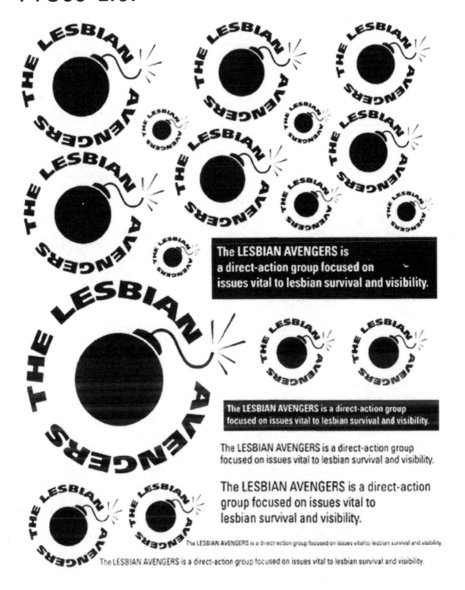

The LESBIAN AVENGERS is a direct-action group focused on issues vital to lesbian survival and visibility.

The LESBIAN AVENGERS is a direct-action group focused on issues vital to lesbian survival and visibility.

The LESBIAN AVENGERS is a direct-action group focused on issues vital to lesbian survival and visibility.

The LESBIAN AVENGERS is a direct-action group focused on issues vital to lesbian survival and visibility.

The LESBIAN AVENGERS is a direct-action group focused on issues vital to lesbian survival and visibility.

The LESBIAN AVENGERS is a direct-action group focused on issues vital to lesbian survival and visibility.

SIGN-UP SHEET

Activity: _____

Contact(s): _____

Date / Time: _____

Place: _____

Name	Phone	Email	Time(s) Available
Jane Doe	555-555-5555	dyxs.doe@gmail.com	mon & tues nights

FINAL ACTION CHECKLIST

	YES	NO
1. Do you have a clear message, dramatic visuals?	☑	☐
2. Does everyone know the action scenario from beginning to end?	☐	☐
3. Have you planned responses to possible contingencies?	☐	☐
4. Have you gotten the word out? (Through social media, posters, mailings, parties, contact with other groups.)	☐	☐
5. Have you leaked info to the media? (Timely press releases and follow-up calls and emails are absolutely essential.)	☐	☐
6. Have you arranged for transportation? (For yourself and your props.)	☐	☐
7. Do you have a fact sheet?	☐	☐
8. Do you have a video person/team?	☐	☐
9. Have you held a CD*training and made sure you know your legal rights and risks?	☐	☐
10. If you expect trouble, do you have marshals, police liaisons, attorneys, legal observers and support people ready?	☐	☐
11. Do you have bail money in case of arrest?	☐	☐
12. Are there health and safety issues you need to address?	☐	☐

*Civil disobedience

LEGAL SUPPORT SHEET

Please fill out both halves.

Name _____ Email _____

Home address _____

Phone _____ Age _____ Date of birth _____

Social Security # _____ Job title _____

Place of employment _____

Work address / phone _____

Person(s) to notify in case of emergency

Name _____ Phone/email _____

Name _____ Phone/email _____

Other (specify medical consideration, work notifications, etc.)

- -

Please fill out both halves.

Name _____ Email _____

Home address _____

Phone _____ Age _____ Date of birth _____

Social Security # _____ Job title _____

Place of employment _____

Work address / phone _____

Person(s) to notify in case of emergency

Name _____ Phone/email _____

Name _____ Phone/email _____

Other (specify medical consideration, work notifications, etc.)

LETTERHEAD FOR PRESS RELEASES

(REPRODUCE BOXED AREA AT 133% FOR 8½" BY 11" FINAL COPY.)

the LESBIAN AVENGERS

The *LESBIAN AVENGERS* is a direct action group focused on issues vital to lesbian survival and visibility

(Use space under tag line to fill in meeting time and place and hotline or general information phone number)

SAMPLE PRESS LIST

Mainstream Outlet	Contact	Phone	Email	@twitter
New York Times	Jane Doe	555-555-5555	dykefriendly@nyt.com	@iluvnyc77

LGBT Outlet	Contact	Phone	Email	@twitter
Homo News	Lez Befriends	555-555-5555	biglez@hn.com	@ilovelesbians2

Español	Contact	Phone	Email	@twitter
El Diario/La Prensa	T. Ortillera	555-555-5555	esa.chica@eld.com	@tortillera92

Blog, site	Contact	Email	@twitter	@insta
All About Dykes	I. N. Fluencer	a.a.@dykes.com	@dykezrule	@dykezrule

Appendix 3:
New York Avenger Graphics

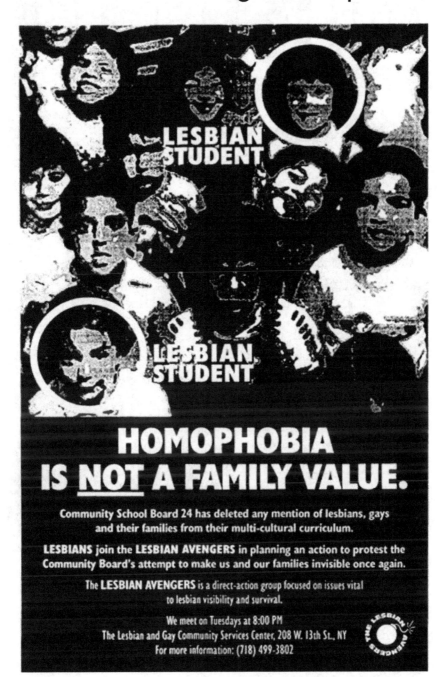

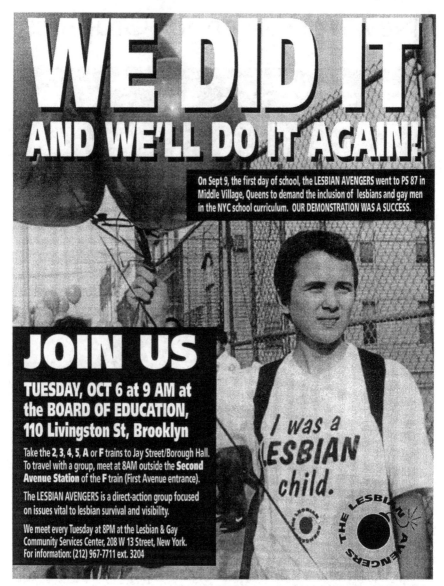

WE DID IT

AND WE'LL DO IT AGAIN!

On Sept 9, the first day of school, the LESBIAN AVENGERS went to PS 87 in Middle Village, Queens to demand the inclusion of lesbians and gay men in the NYC school curriculum. OUR DEMONSTRATION WAS A SUCCESS.

JOIN US

TUESDAY, OCT 6 at 9 AM at the BOARD OF EDUCATION, 110 Livingston St, Brooklyn

Take the **2**, **3**, **4**, **5**, **A** or **F** trains to Jay Street/Borough Hall. To travel with a group, meet at 8AM outside the **Second Avenue Station** of the **F** train (First Avenue entrance).

The LESBIAN AVENGERS is a direct-action group focused on issues vital to lesbian survival and visibility.

We meet every Tuesday at 8PM at the Lesbian & Gay Community Services Center, 208 W 13 Street, New York. For information: (212) 967-7711 ext. 3204

Photo: Donna Binder

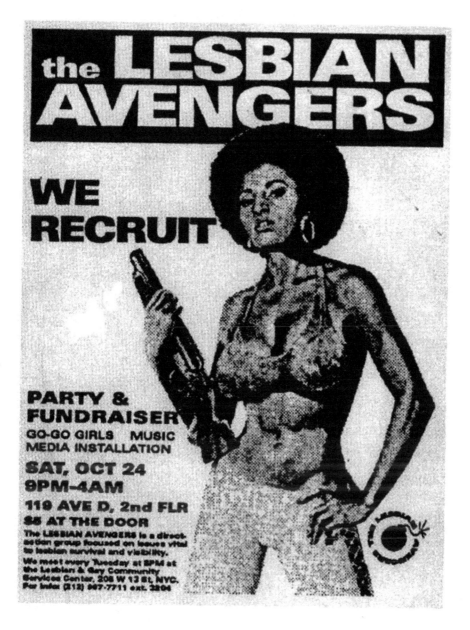

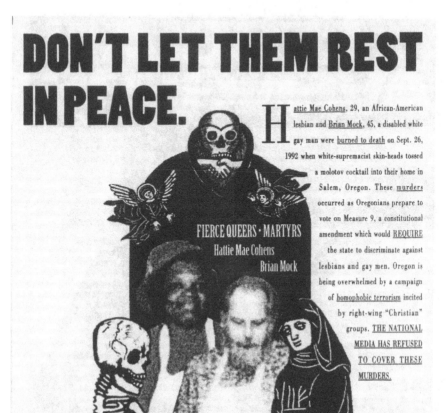

DON'T LET THEM REST IN PEACE.

Hattie Mae Cohens, 29, an African-American lesbian and Brian Mock, 45, a disabled white gay man were burned to death on Sept. 26, 1992 when white-supremacist skin-heads tossed a molotov cocktail into their home in Salem, Oregon. These murders occurred as Oregonians prepare to vote on Measure 9, a constitutional amendment which would REQUIRE the state to discriminate against lesbians and gay men. Oregon is being overwhelmed by a campaign of homophobic terrorism incited by right-wing "Christian" groups. THE NATIONAL MEDIA HAS REFUSED TO COVER THESE MURDERS.

FIERCE QUEERS · MARTYRS
Hattie Mae Cohens
Brian Mock

AVENGE THE OREGON MARTYRS.

LET YOUR ANGER BURN! JOIN THE LESBIAN AVENGERS THURS NOV 19, 4:30 PM IN FRONT OF THE PLAZA HOTEL (5TH AVE & 57TH ST). WE'LL MARCH TO ROCKEFELLER CENTER TO DEMAND MEDIA COVERAGE OF THESE CRIMES.

The LESBIAN AVENGERS is a direct-action group focused on issues vital to lesbian survival and visibility. We meet every Tuesday at 8PM at the Lesbian & Gay Community Services Center, 208 W 13 St, NY. Info: (212) 967-7711 ext. 3204

Image courtesy of Lesbian Herstory Archives

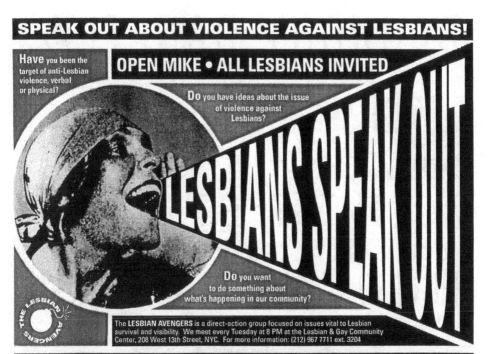

BLOWOUT DANCE!

WITH THE LESBIAN AVENGERS

NEW YEARS EVE 9PM-? $7
PS 122, 150 FIRST AVENUE
(CORNER 1ST AVE/9TH ST)

ACTIVIST GO-GO!

YOUR SEXUAL FUTURE REVEALED

HUNKY GIRLS!

TABLOID VIDEO

BAD FASHION

INCENDIARY
KISSING
BOOTH

TRASH

BOMBSHELLS

THE LESBIAN
AVENGERS IS A
DIRECT-ACTION
GROUP FOCUSED ON
ISSUES VITAL TO
LESBIAN SURVIVAL AND
VISIBILITY. WE MEET
EVERY TUESDAY AT 8 PM
AT THE LESBIAN & GAY
COMMUNITY CENTER, 208 WEST
13TH STREET, NYC. FOR MORE
INFO: (212) 967-7711 EXT. 3204.

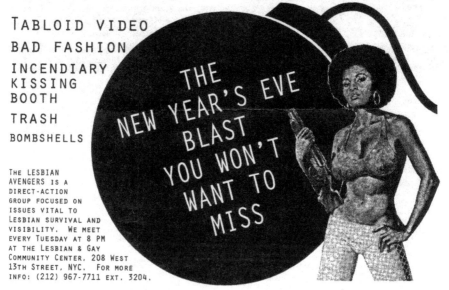

THE NEW YEAR'S EVE BLAST YOU WON'T WANT TO MISS

THE LESBIAN AVENGERS

Join Gertrude Stein & Alice B. Toklas to Celebrate Valentines Day

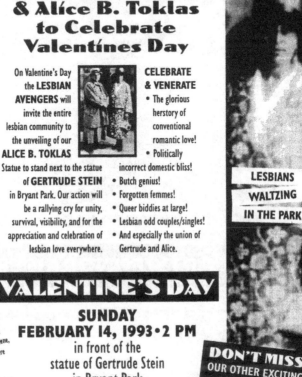

On Valentine's Day the **LESBIAN AVENGERS** will invite the entire lesbian community to the unveiling of our **ALICE B. TOKLAS** Statue to stand next to the statue of **GERTRUDE STEIN** in Bryant Park. Our action will be a rallying cry for unity, survival, visibility, and for the appreciation and celebration of lesbian love everywhere.

CELEBRATE & VENERATE
• The glorious herstory of conventional romantic love!
• Politically incorrect domestic bliss!
• Butch genius!
• Forgotten femmes!
• Queer biddies at large!
• Lesbian odd couples/singles!
• And especially the union of Gertrude and Alice.

READINGS BY:

MARIA IRENE FORNES

JOAN NESTLE

& OTHERS

LESBIANS WALTZING IN THE PARK

VALENTINE'S DAY

SUNDAY
FEBRUARY 14, 1993 • 2 PM
in front of the statue of Gertrude Stein in Bryant Park
(40th St between 5th & 6th Aves)

They were regularly gay there, Helen Furr and Georgine Skeene, they were regularly gay there where they were gay. They were very regularly gay.

To be regularly gay was to do every day the gay thing that they did every day. To be regularly gay was to end every day at the same time after they had been regularly gay. They were regularly gay. They were gay every day. They ended every day in the same way, at the same time, and they had been every day regularly gay.

—"Miss Furr and Miss Skeene"
Gertrude Stein

DON'T MISS
OUR OTHER EXCITING
L-U-V ACTIONS
PLANNED FOR
VALENTINE'S WEEK!

CALL THE AVENGER HOTLINE
FOR INFO: (212) 967-7711 x3204

The **LESBIAN AVENGERS** is a direct-action group focused on issues vital to lesbian survival and visibility.

We meet every Tuesday at 8PM at the Lesbian & Gay Community Services Center, 208 West 13 Street, New York

WASHINGTON OR BUST!

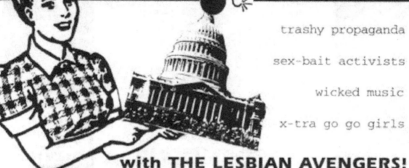

trashy propaganda

sex-bait activists

wicked music

x-tra go go girls

with **THE LESBIAN AVENGERS!**

PARTY/FUNDRAISER

SAT MARCH 20 **9pm - 4am**
119 AVE D - 2nd FLOOR **$5**

JOIN THE LESBIAN AVENGERS in WASHINGTON DC!
SAT APRIL 24 : INCENDIARY DYKE MARCH
SUN APRIL 25: Our own (baddest & loudest) contingent in official march
MON APR 26: LESBIAN AVENGERS! Civil disobedience actions

The LESBIAN AVENGERS is a direct-action group focused on issues vital to
lesbian survival and visibility.
We meet every Tuesday at 8PM at the Lesbian & Gay Community Services
Center, 208 W 13 Street, NYC. For information: (212) 967-7711 ext. 3204

DYKE MANIFESTO

CALLING ALL LESBIANS!

WAKE UP!

IT'S TIME TO GET OUT OF THE BEDS, OUT OF THE BARS AND INTO THE STREETS.
IT'S TIME TO SEIZE THE POWER OF DYKE LOVE, DYKE VISION, DYKE ANGER, DYKE INTELLIGENCE, DYKE STRATEGY.
IT'S TIME TO ORGANIZE AND INCITE. IT'S TIME TO GET TOGETHER AND FIGHT.
WE'RE INVISIBLE, SISTERS, AND IT'S NOT SAFE—NOT IN OUR HOMES, NOT IN THE STREETS, NOT ON THE JOB, NOT IN THE COURTS.
WHERE ARE THE <u>OUT</u> LESBIAN LEADERS? IT'S TIME FOR A FIERCE LESBIAN MOVEMENT AND THAT'S <u>YOU</u>: THE ROLE MODEL, THE VISION, THE DESIRE.

WE NEED YOU.

BECAUSE: WE'RE NOT WAITING FOR THE RAPTURE. WE ARE THE APOCALYPSE. *We'll be your dream and their nightmare.*

LESBIAN POWER

LESBIAN AVENGERS BELIEVE IN CREATIVE ACTIVISM: LOUD, BOLD, SEXY, SILLY, FIERCE, TASTY AND DRAMATIC. ARREST OPTIONAL.
THINK DEMONSTRATIONS ARE A GOOD TIME AND A GREAT PLACE TO CRUISE WOMEN.
LESBIAN AVENGERS DON'T HAVE PATIENCE FOR POLITE POLITICS. ARE BORED WITH THE BOYS.
THINK OF STINK BOMBS AS ALL-SEASON ACCESSORIES. DON'T HAVE A POSITION ON FUR.
LESBIAN AVENGERS BELIEVE CONFRONTATION FOSTERS GROWTH AND STRONG BONES.
BELIEVE IN RECRUITMENT. NOT BY THE ARMY; NOT OF STRAIGHT WOMEN. DON'T MIND HANDCUFFS AT ALL.
LESBIAN AVENGERS DO BELIEVE HOMOPHOBIA IS A FORM OF MISOGYNY.
LESBIAN AVENGERS ARE NOT CONTENT WITH GHETTOES: WE WANT YOUR HOUSE, YOUR JOB, YOUR FREQUENT FLYER MILES.
WE'LL SELL YOUR JEWELRY TO SUBSIDIZE OUR MOVEMENT.
LESBIAN AVENGERS DON'T BELIEVE IN THE FEMINIZATION OF POVERTY. WE DEMAND UNIVERSAL HEALTH INSURANCE AND HOUSING.
WE DEMAND FOOD AND SHELTER FOR ALL HOMELESS LESBIANS.
LESBIAN AVENGERS ARE THE 13th STEP. LESBIAN AVENGERS THINK GIRL GANGS ARE THE WAVE OF THE FUTURE.

LESBIAN SEX

BELIEVE IN TRANSCENDENCE IN ALL STATES, INCLUDING COLORADO AND OREGON.
THINK SEX IS A DAILY LIBATION: GOOD ENERGY FOR ACTIONS.
CRAVE, ENJOY, EXPLORE, SUFFER FROM NEW IDEAS ABOUT RELATIONSHIPS:
SLUMBER PARTIES. POLYGAMY (WHY GET MARRIED ONLY ONCE?). PERSONAL ADS. AFFINITY GROUPS.
ARE OLD FASHIONED: PINE, LONG, WHINE, STAY IN BAD RELATIONSHIPS.
GET MARRIED BUT DON'T WANT TO DOMESTICATE OUR PARTNERS.
LESBIAN AVENGERS LIKE THE SONG "MORE MADONNA, LESS JESUS"
USE LIVE ACTION WORDS: *lick, waltz, eat, fuck, kiss, plug, bite, give it up.*
LESBIAN AVENGERS LIKE JINGLES: SUBVERSION IS OUR PERVERSION.

LESBIAN ACTIVISM

LESBIAN AVENGERS SCHEME AND SCREAM.
THINK ACTIONS MUST BE LOCAL, REGIONAL, NATIONAL, GLOBAL, COSMIC.
LESBIAN AVENGERS THINK CLOSETED LESBIANS, QUEER BOYS AND SYMPATHETIC STRAIGHTS SHOULD SEND US MONEY.
BELIEVE DIRECT ACTION IS A KICK IN THE FACE.
LESBIAN AVENGERS PLAN TO TARGET HOMOPHOBES OF EVERY STRIPE AND INFILTRATE THE CHRISTIAN RIGHT.
LESBIAN AVENGERS ENJOY LITIGATION. *Class action suits fit us very well.*

TOP 10 AVENGER QUALITIES

(IN DESCENDING ORDER)

10. COMPASSION
9. LEADERSHIP
8. NO BIG EGO
7. INFORMED
6. FEARLESSNESS
5. RIGHTEOUS ANGER
4. FIGHTING SPIRIT
3. PRO SEX
2. GOOD DANCER
1. ACCESS TO RESOURCES (XEROX MACHINES)

THE LESBIAN AVENGERS. WE RECRUIT.

Appendix 4:
Communiqués From The Frontline

COMMUNIQUÉ Nº 1
FROM THE FRONTLINE

DECEMBER 1992—Wellington Webb, the **MAYOR OF DENVER**, was about to fork his eggs over easy under the indulgent gaze of a Wall Street Journal senior editor when eight **LESBIAN AVENGERS** broke into the plush **REGENCY HOTEL DINING ROOM** chanting at the top of their lungs "We're here. We're queer. And we're not going skiing!" and "Boycott Colorado!" The Mayor had come to New York to promote tourism and investments in Colorado—**THE HATE STATE.** It was about 9 a.m., Monday Dec. 7—a day the Regency power-breakfasters will never forget—**THE DAY WHEN THEY LEARNED THAT YOU CAN'T HIDE FROM THE LESBIAN AVENGERS.**

While hotel security frantically cackled about like headless chickens, the unstoppable Avengers stomped around the room for three triumphant tours, noisily waving placards and giving leaflets to all, including the Mayor. Next morning, the story was all over the front page of the Colorado press. The message: there's a price to be paid, in dollars and cents, when a state deprives its lesbian and gay citizens of all civil rights protection, as Colorado did on November 2 when it added the hateful Amendment 2 to its constitution.

After the Regency fracas, it was all uphill for the Mayor's damage control visit to New York. Proving once again that a small group of fearless **AVENGERS** can wreak considerable political havoc in a few hours, **WE DOGGED HIM ALL DAY** Monday and Tuesday Dec. 8.

from ABC to Time, from The New York Times to Newsweek, from the Plaza Hotel to City Hall. To cap it all, about 80 people loudly demonstrated with us on Monday night in front of the CBS Broadcast Center while the Mayor was doing a radio interview inside.

By the end of his trip, a plaintive Mayor Webb was telling the press that he had come to New York City to talk about tourism and investment and all everyone wanted to talk about was Amendment 2 and "Boycott Colorado". Thanks, in part to Lesbian Avenger pressure in the streets, his trip to woo New York's media, business and political establishments away from a boycott backfired, with **MAYOR DINKINS** publicly endorsing a tourism boycott and lots of bad press here and back at the ranch. Mission accomplished.

Throughout our two-day action, we carefully kept the focus on the "Boycott Colorado" issue, avoiding any personal attack against Mayor Webb. The Mayor, an African-American, had strongly opposed Amendment 2 before it was adopted; we urged him "to continue his outspoken support."

THUS THE YEAR ENDS IN A FIERY WHIRLWIND OF LESBIAN AVENGER ACTIVITY. In the three months since we first took to the streets with a vengeance, we've lit New York City's political fuse on three issues vital to lesbian survival: the campaign to erase lesbians and

gay men from NYC's multicultural curriculum; the Colorado boycott; and violence against us, as exemplified by the murders of Hattie Mae Cohens and Brian Mock, a Black lesbian and a disabled white gay man, burned to death in Oregon on Sept. 26, as that state prepared to vote on the homophobic Measure 9, which was later narrowly defeated. All three issues were languishing in relative obscurity until **WE LIT THE FUSE.**

Since September, we have given lavender balloons inscribed "Ask about Lesbian Lives" to Queens first-graders to the tune of "When the Dykes Come Marching In" played by **THE AVENGER MARCHING BAND** and we made a mess of the Fifth Avenue-holiday shopper-mania when we took to the streets with lit torches to protest the Oregon murders. We staged a five-day around-the-clock encampment in the West Village before a shrine dedicated to those murdered in Oregon and elsewhere and we organized a well-attended speak-out on violence against lesbians. We have demonstrated twice before the Board of Education, attended local School Board meetings, created an Avenger video group, and thrown three fabulous parties—the fourth and most fabulous being the New Year's Eve party you'd be a real fool to miss.

So, it's not immodest to say that we're HOT, HAPPENING and BUSY. **And yes, Mary: WE WANT YOU.** We want you if you want revenge. If you're sick and tired of being

invisible. If you refuse to be trampled on any more. If you thirst for **RETALIATION.** If you're ready and raging to take to the streets!

WE WANT YOU. When you're ready, of course. And we give you several options. You can: A) **COME TO A TUESDAY MEETING** (8PM at the Lesbian & Gay Community Services Center, 208 W 13th St); B) **CALL THE AVENGER HOTLINE (212-967-7711 x3204)** and leave a message asking for information on where the Avengers are going to strike next and just show up; or C) keep coming to our strenuously fabulous parties until you're ready for options A or B.

Oh, if you're very rich, or just a little rich, there's also another option, Option D: give us a check. We also take cash, money orders, travellers checks, and the family jewels, especially if they're engraved with names like "Xerox" or "Sony".

THINK ABOUT IT. Being nice isn't going to get you anywhere. Nice, obedient girls always end up lying under the master's table, like doggies, eating his crumbs. **WERE YOU BORN TO HIDE AND SEETHE? NOT.** Besides, with the religious right out to get us, there's really no place for you to hide. You've got nothing to lose but your frustrations. Be disorderly! **BE UNRULY! GET EVEN! JOIN THE LESBIAN AVENGERS AND JOIN THE RIOT. WE RECRUIT.**

See you later.
The Lesbian Avengers

COMMUNIQUÉ Nº 2

FROM THE FRONTLINE

FEBRUARY 1993—The year started off with a bang at the Lesbian Avengers' New Year's Eve party. As go-go girls undulated out the old year, hundreds of hot, pulsating dykes boogied in the new to raise $5,000 for the year's avenging.

The cash we raised didn't burn a hole in our pockets. Within the week, the **Lesbian Avengers** were out in force to defend the **Rainbow Curriculum.** On January 6th, some 50 Avengers braved the cold to teach the ABCs of respect to members of the **United Federation of Teachers** (UFT) who had gathered for their general delegates meeting. Sporting placards with slogans based on the letters of the alphabet, Avengers distributed hundreds of leaflets to those entering and leaving the meeting, urging them to support the curriculum, their queer colleagues, and queer kids. The action put pressure on the UFT, particularly union president and waffling Rainbow advocate Sandra Feldman, to put full force behind the Rainbow Curriculum, grades 1-12.

In a homophobic world, a Lesbian Avenger's work is never done, and so just three weeks later those dazzling dykes were at it again. This time, our aim was **Self** destructive. The big boys at **Self Magazine** evidently thought no one was watching when they decided to go ahead with a staff ski trip to Aspen, Colorado, with full knowledge of the state's passage in November of the hateful Amendment 2, which deprives queer citizens of civil rights protection. But, proving the

time-worn adage that we are everywhere, Lesbian Avengers were there to show them that bigotry is bad for business. At 11:30 a.m., a dozen **Lesbian Avengers stormed the chic Madison Avenue offices of Conde Nast** to protest the proposed sojourn in the Hate State. Chanting "Boycott Colorado," "We're here. We're queer. And we're not going skiing," and handing out fact sheets on Amendment 2, the Avengers struck fear and awe into the hearts of onlookers, inspiring a rumor that they were packing guns. While gray-suited security guards looked on meekly and editor Alexandra Penney retreated to her office, the Avengers held their ground. When Penney made a dash for her limo soon after, she had to wade through a line of Avengers picketing on the sidewalk outside. The trip was cancelled the next day.

From boardroom to courtroom, Lesbian Avengers were on the watch. At the sentencing of convicted **lesbian basher Freddy Garcia,** Judge Madden gave an inspired speech about the victim's heroism only to let Garcia off with a slap on the hand. The courtroom erupted with enraged Avengers. Garcia had been sentenced to 200 hours of community service in the office of Marjorie Hill, the mayor's liaison to the gay and lesbian community, allegedly on Hill's recommendation. Lesbian Avengers marched into Hill's office to demand an explanation. Hill denied having made the recom-

mendation and agreed not to let Garcia or other convicted bashers work in the office. Not all the Avengers' actions are in your face. Sometimes they're in your nose. The lunch-hour crowds who entered the foul-smelling elevator of the Bar Building on February 12 didn't have to wait long to find out where the stench was coming from. When the elevator doors closed, they revealed giant stickers announcing **"Homophobia Stinks,"** dedicated by the Avengers to **Jack Hale,** lawyer for the Archdiocese. Stink bombings also took place at the **Forty-second Street Army Recruitment Center** and **St. Patrick's Cathedral.** These were the first wave of the **guerrilla Valentines** launched by the Lesbian Avengers in February. On Valentine's Eve, the Avengers staged a **skate-in** at the Rockefeller Center ice rink; dykes skated arm-in-arm and kissed before the amazed Saturday afternoon crowds. That night, Avengers braved the cold to serenade the bigoted enemy of the Rainbow Curriculum, **Mary Cummins** at her home in Queens. And on Valentine's Day, 250 dykes gathered to witness the unveiling of a statue of **Alice B. Toklas** in Bryant Park where she was reunited with her lover **Gertrude Stein.** Readings by prominent lesbian writers followed, culminating in joyous **lesbian waltzing** amidst the scintillating snow. The actions, which drew crowds and media attention, capped off the Lesbian Avenger's

rough and retributive itinerary for the first six weeks of the year. And now we have **four new chapters** of Avenging lesbians—in **Atlanta, Durham, Austin** and **Tucson.**

Time and again the Lesbian Avengers have proved that good politics can be a good time. And now, you're asking, "How can I become a part of this fabulous, funky, and fierce group of dykes?" Money's always good, so come to our mouth-watering March 20th dance (Saturday, 9pm, March 20, 119 Avenue D, 2nd floor). **LET US PUT YOU ON THE ROAD TO REVENGE.**

WE WANT YOU. If you are fed up with being ignored, with fighting for everyone's rights but your own, then come and join the Avengers. There's a lot you can do. Come to a Tuesday meeting (8pm at the Lesbian and Gay Community Services Center, 208 W 13th St).

CALL THE LESBIAN AVENGERS HOTLINE 212-967-7711 x3204 and leave a message asking for information on the Avengers next target. Better yet, join us in coordinating the first national Lesbian Avengers-sponsored action the weekend of the March on Washington, DC (April 24th). Then join us for the march itself where we will be out in force and **OUT FOR POWER.** And if you make a fashion statement, Lesbian Avengers t-shirts are just $10. (Our video is just $13.95.)

GET MAD! GET EVEN! JOIN THE LESBIAN AVENGERS AND JOIN THE RIOT. WE RECRUIT.

COMMUNIQUÉ No 3

FROM THE FRONTLINE

JUNE 1993—Almost a year after our collective explosion into the world of direct action, the Lesbian Avengers are still raising hell, lighting fuses and breaking hearts. Our March 20th benefit got those tender dyke hearts pounding. Once again hundreds of lesbian revelers thrilled to the sights and sounds of **go-go girl boogie fever**, raising thousands of dollars for our Washington, DC exploits. As Avenger chapters spring up around the country, most recently in **Minneapolis, Boston, and Houston**, New York dykes are still giving lesbophobes the most bang for your buck.

On **St. Patrick's day**, scores of soaked but feisty Avengers joined the Irish Lesbian and Gay Organization to protest their exclusion from the parade, which **Mayor Dinkins** had made city policy with 2 (count 'em, 2) injunctions against ILGO. As Avengers were cuffed and piled into vans, supporters countered with rousing Irish ditties. And to jail we went, with the tune of **"As Irish Dykes are Smiling"** ringing in our ears.

Arrests don't slow Avengers down. We renewed our vigilance at dyke hating school board meetings and spoke up for **kiddie queers and lesbian moms**. We crashed a forum on New York public schools and showed bigoted educators what true Avenger fury was all about. Together with other powerful queer advocates we invaded the **Brooklyn Conservative Party** to show our outrage over their award to notorious antimulticultural curriculum hatemonger Mary Cummins. **From schoolhouse to jailhouse,** Avengers fought for dykes everywhere. After witnessing the death penalty railroading of **accused**

'lesbian serial killer" Aileen Wuornos, a group of Avengers contacted Wuornos in support of her case. The Avengers received a letter from Wuornos, who is currently on Florida's death row, and are working to publicize her case and the homophobia and misogyny of the **Florida court system.**

Our finest hour came in our weekend of actions in **Washington, D.C.**, April 23 to 26. On our first day in D.C., the Avengers joined ACT-UP/NY's lesbian caucus outside the **Health and Human Services** building to demand research on lesbians with AIDS. While 350 riled and raucous dykes rallied outside and lesbians with AIDS spoke out about their lives, 19 ACT-UP and Avenger women, 16 of them lesbians with AIDS, met with HHS secretary **Donna Shalala**. Shalala was so impressed with these forceful and eloquent women that she extended the planned meeting time from 5 minutes to half an hour, listening to lesbians talk about **research, treatment, housing and homophobia.**

"But wait!" you exclaim. **Don't those irrepressible Lesbian Avengers have any fun?** If you'd been to our D.C. Dyke March on April 24 you'd know the answer. In coalition with dykes from around the country, the Lesbian Avengers threw **the largest lesbian march in history**. We had handed out 8,000 palm cards before the march, but even we were overwhelmed by the response. Almost 20,000 fierce dykes took over D.C. that Saturday night, stretching from Dupont Circle to the White House. As crowds of

lesbians filled the streets, **incandescent Avengers ate fire in front of the White House**, spoke out on the Ellipse, and for one night turned the nation's capital into a shimmering lesbian universe. We handed out thousands of our "Dyke Manifesto," an incendiary broadsheet urging lesbians to wake up and take action. The day of the March on Washington, Lesbian Avengers dressed for the occasion in superdyke action capes and Avenger t-shirts. **Dykes from Montana to Maine joined us on the road to recruitment and rabble rousing.** And no trip to D.C. would be complete without an invasion of the halls of power. On the next day 7 or 8 Avengers crept into the **House of Representatives** and stood in the gallery. They set off stink bombs and plastered the walls with **"Homophobia Stinks"** stickers as 2 busloads of Avengers, ACT-UP members and other assorted activists were arrested outside demanding equitable health care.

But with every breakthrough comes a backlash. Back in New York we learned that Dee DeBerry, a visible dyke with HIV who had been threatened with the **firebombing** of her trailer if she went to Washington, returned to **Tampa, FL**, to find that indeed her home had been destroyed. Her courage has inspired us, and once again we're out for vengeance, for her and all dykes. The Avengers are descending on Tampa to support Dee and all **lesbians living with the threat of violence**. On Sunday, June 13 we'll hold a candlelight vigil at the site of Dee's home, and on Monday, June 14, we'll

stage an action in downtown Tampa to let the homophobes know that we won't let their actions go unnoticed. The Lesbian Avengers won't rest until all dykes have retribution.

And we won't rest until we've shown the world that "**Lesbians Lust for Power!**" We're kicking off Lesbian & Gay Pride weekend with a march to celebrate dyke desire. Come out on June 26 and **practice the art of mass seduction** as we lick, squirm, fondle, moan and kiss our way down Broadway from Bryant Park to the Pride rally at Union Square.

Word is getting around. From Newsweek to New York Magazine, Deneuve to Mademoiselle, Radical Chick to CNN, the country is waking up to Avenger time. **Revenge is sweet** and so are rough, activist lesbians. If invisibility and lesbophobia are getting you down, join us! Come to our meetings—Tuesdays at 8pm, at the Lesbian and Gay Community Services Center, 208 W.13th Street).

CALL THE LESBIAN AVENGERS HOTLINE 212-967-7711 x3204

and leave a message asking for information on the Avengers' next target or about Avenger chapters in your area. Wear a Lesbian Avenger t-shirt (still only $10) with pride and fury.

The Lesbian Avengers is a direct action group focused on issues vital to lesbian survival and visibility.

GET MAD! GET EVEN! JOIN THE LESBIAN AVENGERS AND JOIN THE RIOT. WE RECRUIT.

COMMUNIQUÉ Nº 4

FROM THE FRONTLINE

February 1994—Those feisty Lesbian Avengers are at it again! **Neither rain, nor sleet nor pesky homophobes will stop our fight** against queer-hating bigots!

Lesbian Avengers **showed our power** when, on the weekend of June 13th, thirty of us flew down to **Tampa, Florida** with women from ACT UP/New York to support Dee DeBerry, an out dyke with HIV whose house had been firebombed by bigots while she was at the March on Washington in April. We worked with the newly-formed Tampa/St. Petersburg Avengers to **let the homophobes know that their actions weren't going unnoticed.**

Our first night in Tampa we hit the bars to talk to dykes about our plans and to incite them to action. The next day **we mixed frolicking in the ocean with serious grassroots organizing and outreach** to tanned and bikinied babes. That night, together with lesbians who had traveled from Austin TX, Durham, NC, Atlanta, GA and Chicago, we marched by candlelight through the trailer park that held the burned-out shell of Dee's home.

Early the next morning, Tampa **commuters felt the effects of Lesbian Avenger wrath** when we slowed rush hour traffic to a near standstill on the major freeway. On the steps of Tampa City Hall we called on Mayor Sandy Freedman to classify the bombing of Dee's home as a hate crime and to speak out against

the recent repealing of the city's Human Rights Ordinance protecting the civil rights of queers and people with AIDS. Of course, **Avengers are too fabulous to go unnoticed**— Mayor Freedman came out of her office and onto the street to meet with us, and local TV news stations made our actions the lead news story three nights in a row.

Back in New York, Avengers geared up for our **first annual NYC Dyke Pride March,** June 26th. Always good with our hands, the Lesbian Avengers built a massive bed, which we rolled down Broadway from 42nd Street to the Lesbian and Gay Pride Rally in Union Square Park. The bed, covered with **undulating, lustful activist lesbians,** was the centerpiece to our theme: Lesbians Lust for Power. Our **desire is a powerful world-rocking force** that moves us to demand respect and civil rights for lesbians everywhere.

A year after the Avengers first leaped into action by handing out palm cards to eager dykes at the Lesbian/Gay Pride 1992, we were distributing our incendiary broadsheets and marching as a loud bold fierce contingent in the 1993 Pride March—complete with **capes, shields and marching band**—calling lesbians everywhere to join us in our fight for power.

And that power was going to

come without compromise.

When we learned that the Campaign for Military Service was holding a fundraiser on board the USS Intrepid, a symbol of US military aggression, the Lesbian Avengers took the opportunity to remind the CFMS that **they'd left dykes out in the cold** by choosing white male poster boys to fight the ban against open queers in the military. We picketed the Intrepid and confronted CFMS director Tom Stoddard about the organization's elitism and the **US military's violence, racism and misogyny.**

In May/June we supported Avenger volunteer attorney Karen Moulding in a **successful legal battle** against the man who had brutally attacked her.

We didn't let the dog days of August get us down. An Avenger **kiss-in at sunset** on the Staten Island Ferry brought scores of dykes lip-to-lip as we circled our favorite lesbian, Lady Liberty. Later that month we took to the streets in force, protesting President Clinton's August 13th meeting with the Pope in **the hate state** of Colorado. We stopped outside the Military Recruitment Center in Times Square to speak out against **Clinton's waffling on the persecution of queers** in the armed forces. We then went on to Covenant House, a Catholic Church-funded home for runaway kids that refuses to teach safer sex or distribute condoms to

at-risk youth, and to the Catholic-run St. Vincent's Hospital in Greenwich Village. The march ended with the **burning of U.S. and Papal flags** at Sheridan Square in the Village.

As the summer came to a close, we geared up for our **Fall Offensive.** In response to the explosion of anti-queer referenda around the country, the Lesbian Avengers decided to mount our own offensive against hatred. We targeted **Lewiston, Maine,** where Christian Right forces were trying to repeal an existing civil rights ordinance outlawing discrimination on the basis of sexual orientation. Two Avengers headed to Lewiston for **six weeks of full-time organizing** before the November 2nd vote, while dozens of others planned for weekend visits to help local Lewiston queers in their fight against the initiative.

Following the example of activists during the civil rights struggles of the mid-1960s, we also organized a **Freedom Ride** the week of October 8th to 15th: a cross-state road trip throughout the Northeast to meet with lesbians about **mobilizing to fight the Christian Right,** with Lewiston as our final destination. Along the way we held a forum in each town to show *Gay Rights, Special Rights,* the homophobic propaganda video put out by the Traditional Values Coalition; it attempts to pit people-of-color communities against lesbian and gay communities, perpetuating the myth that the two are mutually

exclusive. We also showed our own new video, *Lesbian Avengers Eat Fire Too.*

Barreling into Boston, Avengers hosted a forum at the national *Out Write* Conference for queer writers and ate fire in front of the Boston Public Library to bring attention to Christian Right activity in the area.

We then headed for Northampton **(Lesbianville, USA)** to join luscious lesbians there in a loud **Coming Out Day** march on City Hall on October 11th.

In Albany, NY we stormed the New York State School Board offices to protest Pat Robertson's speaking at the **State School Board Convention.** Outside the building, Avengers dressed in schoolgirl attire, jumped rope, sang **lesbian-positive jump rope chants,** handed out fact sheets on violence against lesbian and gay youth and lollipops with tags reading "Lesbians Taste Good! Lick Homophobia!" In near-by Syracuse, we held our forum, ate brunch with Radical Faeries and hit the local mall in a **"Lesbians Go Shopping" visibility action.** At Hamilton College we invaded the dining halls singing lesbian songs, handing out lollipops and **shocking straight frat boys.**

In Burlington, VT we were welcomed by local dykes at our largest forum—nearly 80 lesbians in attendance— and participated in a **"Lesbian Fall Foliage Festival"** in an open mall in the center of town.

Finally, we reached Lewiston, ME to join Avengers, Equal Protection Lewiston and the Under Thirty's Committee in outreach at local bars and door-to-door leafleting. There, Avengers had been running an openly lesbian and gay campaign focusing on grassroots

community organizing, **voter registration and political and visibility events.** Avenger efforts targeted low income, predominantly Franco-American areas, purposefully neglected by EPL campaign organizers. Avengers also held a forum on the Christian Right at nearby Bates College, a round-table discussion by local lesbians and gay men on what the anti-discrimination ordinance meant to them and a visibility speak-out for openly lesbian and gay members of the community. It had the **largest public turn-out of lesbians and gay men** in the history of Lewiston.

Meanwhile, Avengers back in New York were not idle. We leafletted on the L train to Williamsburg—a train and a neighborhood that had witnessed three queer bashings in the months of September and October. We **infiltrated a speech by Senate Armed Forces Committee Chairman Sam Nunn** at the 92nd Street YMHA on October 13th and interrupted his presentation by standing and reciting our own **pledge of allegiance—"to the dykes and fags of America."** Security guards at the Y turned violent, and in response we organized a series of actions to let the Y know that such **dyke bashing will not be tolerated.**

On Halloween, we set up our **annual shrine** on the corner of Bleecker and Sixth Avenue to call attention to homophobic legislation which fosters violence against lesbians and gay men. Up in Maine, outraged that the initiative repealing the anti-

discrimination ordinance passed on November 2nd, Avengers there took to the streets of Lewiston with local queer activists to let people know that **dykes will not be silenced.** Also in November, the Lesbian Avengers Civil Rights Organizing Project was founded to establish **grassroots lesbian and gay controlled rural organizing projects** in states facing anti-queer referenda in 1994.

"Wait!" you cry. **"Don't those Avengers ever stop?"** Well, ease your spinning head by watching our new video, *Lesbian Avengers Eat Fire Too,* which chronicles our work from our first action in Queens, September 1992, to our trip to Tampa this past summer ($15 for 50 minutes of thrilling Avenger activity!) Or get a piece of the action at our weekly meetings—Tuesdays at 8 pm at the Lesbian and Gay Community Center (208 W. 13th Street).

CALL THE LESBIAN AVENGERS HOTLINE 212-967-7711 x3204

Start an Avenger chapter in your town—just read our newly updated *Lesbian Avenger Handbook,* Wear a Lesbian Avengers t-shirt (yes, still only $10) with a vengeance.

We're not stopping now. Join thousands of dykes from all over the world at the great **International Dyke March** and **Dyke Ball** we are organizing in NYC the last weekend in June, the eve of the 25th Anniversary of the Stonewall rebellion. We're out for power, and we won't rest until every lesbian can come out with pride.

GET MAD! GET EVEN! JOIN THE LESBIAN AVENGERS AND JOIN THE RIOT. WE RECRUIT.

Communiqué text by Sara Chinn and Hadar Dubowsky. Design by Carrie Moyer. Production by Amy Parker, Ana Simo and Kelly Cogswell.

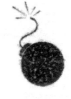

52

Volume 1 Issue 1 May 1994

The Lesbian Avengers
International Communique

Introduction

WELCOME to the First International Lesbian Avenger Communique!

Avengers have been swarming across the continent in recent months, fiercely fighting for lesbian survival and visibility. Growing famous for our creativity, tenacity and humor, the Avengers are shaking things up. What follows is a compilation of daring Avenger deeds from some of the chapters.

Table of Contents

Chapter	Page
National News	1
Camp Sister Spirit	2
Portland, OR	3
E. Lansing, MI	5
Minneapolis, MN	6
San Francisco, CA	8
Atlanta, GA	10
Durham, NC	12
New Orleans, LA	13
Denver, CO	14
New York, NY	15
Austin, TX	16
Santa Cruz, CA	16
Seattle, WA	17

US National News

STONEWALL 25

The New York Avengers are very hard at work planning the event we are all looking forward to: The International Dyke March to be held in New York City on June 25. Details from NY Avengers are forthcoming; we can't wait to hear what's up!

The Austin chapter has been working furiously to plan the Lesbian Pride Ride through the Deep South. Vans will leave Houston on June 16 and arrive in NYC for a welcoming party Fri. June 24 and all of the fabulous Stonewall 25 activities. Highlights of the trip include actions in Vidor, TX (Klan country), New Orleans, Montgomery, Durham, and Washington, D.C. Visits to Camp Sister Spirit in Ovett, Ms, and Sam Nunn's house in Atlanta, GA. and a day at Rehokboth Beach, DE. are planned. The ride is limited to 50 dykes, so a $50 deposit is suggested to hold your seat. Transportation cost is $150 and scholarships are available on the basis of need. Women of color are encouraged to apply.

Minneapolis Avengers are organizing a Northern Avenger Stonewall Caravan. The particulars of the caravan are as follows: Avenger gals will leave Mpls Monday morning, June 20. We will arrive in Cincinnati that night, do an action with Cincinnati lesbians the next morning, and arrive in Pittsburgh Tuesday night, June 21. After some hell-raising in Pittsburgh the next morning, we plan to arrive in NYC Wednesday night, June 22, with plenty of time to settle into town before all the activity for the weekend. All interested Avengers between Mpls and NYC should contact us in Mpls to coordinate with the caravan (612-███ Dipping down to Cincinnati may make the route too Southerly for Avengers from E. Lansing, Detroit, Guelph, Ontario or even Cleveland, but women from St. Louis and elsewhere in Ohio may well be interested in meeting us in Sin City. Also, gals could plan to hook up in Pittsburgh, especially when (and if!) we can make contact with Avengers in the new chapter there.

See y'all in NYC!

LESBIAN AVENGERS CIVIL RIGHTS ORGANIZING PROJECT

The Lesbian Avengers Civil Rights Organizing Project was founded this fall after Avengers from New York travelled to Lewiston, Maine, to work with Queers in that city. Lewiston was facing a repeal of its anti-

Production
Natasha King
Hillary Smith

Contributors

Misha Anisoski
Swampy Cloud
Margo Gardiner
Wendy Kramer
Stephanie Mulligan

and all you wonderful gals who sent in stuff

discrimination ordinance, and Avengers spent six weeks there helping to fight an Out campaign. Gleaning insights from their experiences in Lewiston, the Civil Rights Organizing Project was formed to focus on a nation-wide campaign against the Christian Right's anti-lesbian and -gay initiatives.

The Civil Rights Organizing Project's first mission is the production of a four page manifesto to be distributed at Stonewall 25. Named "Out Against the Right," the manifesto is based on the following beliefs:

1. We, as lesbian, gay and bisexual people, must define and lead our own struggles for human rights. The mobilization and empowerment of lesbian, gay and bisexual communities is the most critical response to the Christian Right's war on our right to exist.

2. Lesbians of all colors and gay men of color must attain a strong and equal voice within our own lesbian and gay communities. Unless we do so, our efforts towards the securing of our civil rights will only reproduce existing power structures within the community at large.

3. We will not accept superficial legal rights for some lesbians and gay men at the expense of real human rights for all of us. Butch, femme and androgynous dykes, lesbians and gay men of color, drag queens, lesbian and gay youth, transsexuals, people with AIDS, and rural lesbians and gay men will not be sacrificed in the name of "campaign strategy." We have no desire to win a battle if it means losing the war.

4. The Christian Right is capitalizing on fears created by the economic depression and on people's experiences of being politically ignored. Our referenda campaigns will emerge from work in low-income communities, communities of color and rural communities and will forge grassroots alliances among all people concerned about human rights and social change.

5. Voters will not stand up for the rights of an invisible community. We need to use the anti-initiative campaigns to gain political power by educating straight people, honestly and openly, about lesbian, gay and bisexual lives.

Concurrently, the Civil Rights Organizing Project is working on an "Out Against the Right" Handbook, which will detail political strategies outlined in the manifesto. The handbook will be distributed free of charge to activists living in cities and states facing anti-queer ballot measure initiatives.

Beginning in mid-July, the Lesbian Avengers will go on-site in states where local queer activists request their assistance. Once there, the Avengers will work with local activists in implementing projects that encourage mobilizing our communities in an out, visible fight against the Christian Right.

Watch for the Out Against the Right manifesto at Stonewall 25, or write to:

The Lesbian Avengers
Attn: Civil Rights Organizing Project
208 W. 13th Street
New York, NY 10011

Camp Sister Spirit

Lesbian Avengers across the continent have been rising to the call for help from Brenda and Wanda Henson. The Hensons bought land in Ovett, Mississippi with intentions of starting a refuge and education center for women. However, members of the Ovett community, upon learning that the Hensons are lesbians, have responded with rampant homophobia. The Hensons have been continually harassed, have found a dead female dog on their mailbox, and have received death threats. They need support, money for legal assistance, and women to stay with them on their land.

Avenger chapters have responded in many ways. The San Francisco Lesbian Avengers and WAC (Women's Action Coalition) hosted an informal and intimate gathering of about 50-60 women who were given the opportunity to visit and speak with the Hensons personally. The benefit capped a full weekend of fundraising activities, including tabling in the Castro district with the Avengers. The Hensons spoke to their admiring crowd of supporters sharing their terrifying experiences on the land, including a recent attack on one of their caretakers. Wanda Henson urged all of us in San Francisco transplanted from other parts of the country to move back to our hometowns and come

Deputy Sheriff Myron Holifield opposes a lesbian retreat, Camp Sister Spirit, in Ovett, Miss., because "It's a known fact that all your violent crime comes from homosexuals."

out. The Avengers showcased their culinary talents by cooking up a mean vegetarian chili and cornbread to feed the crowd and a few tired activists. Avenger Jeanette, a transplanted Texan, serenaded the Hensons and got the entire crowd into the spirit of the evening with a Camp Sister Spirit campfire song that she wrote and performed especially for the benefit.

In early April, Wanda Henson came to Minneapolis to talk about Camp Sister Spirit. Avengers called a meeting to follow up her talk the next week, and a local support committee was formed which will be filled with but not exclusive to Avengers. The Hensons need all the help they can get, and even though we work our butts off doing work in this town, not every lesbian feels comfortable with what our bomb logo represents (their loss). So we decided to start a semi-autonomous group to maximize local support and fundraising for Sister Spirit, Inc. After doing fundraising this spring, many of us plan to go down to Ovett during the summer.

Lesbian Avengers from Lansing, Atlanta, Durham, Austin and New Orleans have all been to Camp Sister Spirit to offer support. Avengers from Portland, New York and Durham have held fundraisers to raise money and awareness. Support for the Hensons is continuing across the continent.

As property lines become front lines we salute them in solidarity.

Portland, OR

Greetings from the Beaver State! This past month a county circuit court judge ruled the Oregon Citizen Alliance's latest anti-queer initiative unconstitutional because the initiative covers more than one topic. However, celebrations

Page 3

aren't yet in order, because the OCA is appealing the ruling and the initiative is expected to be on the November 1994 ballot. The OCA also has already filed two anti-lesbian and -gay initiatives for the 1996 ballot. Oregon Queers, once again, have our work cut out for us. Let me tell you sisters, these battles are a huge drain on our communities, but there's nothing like some fierce, out, proud dyke activism to get a girl revitalized!

In September the Portland Avengers responded to the frequent queer bashings on Portland's Tri-Met bus system. Both bus drivers and passengers have shown a horrific lack of response or intervention to situations dangerous to queer bus riders. Last summer, three boys verbally assaulted a lesbian on a bus, calling her a "Dyke." When she responded with "You look like a pretty weak boy to me," one of them punched her in the face. The bus driver and fellow passengers did nothing. Ironically, also last summer, two African-American men who were drinking on the bus were considered "threatening" by the bus driver, who called the police. The cops showed up, chased the men, and then shot at one of them 27 times. We are outraged at the double standard in which innocent African-American men are persecuted while Queer-bashers get a free ride.

For the action, entitled "Tri-a-Dyke" after the Tri-Met bus system, we built a fabulous cardboard "Queer Friendly Bus" and cruised around the downtown transit mall at rush hour. Our bus was decorated with slogans such as "Straight life got you down? Join Us!" and "Ride my ass!

Direct route to all erogenous zones." We passed out handbills in the form of bus transfers and sang "Another dyke rides the bus" to the tune of the Queen hit. We had a fantastic time!

Last October at Portland State University, a pernicious rubber-stamped message appeared on women's studies flyers and in restrooms all over campus. The

ZAP

message said "KICK A DYKE IN THE CUNT," but despite the maliciousness of the stamp, the PSU administration and student body were silent.

So, the Portland Lesbian Avengers were called into action by an Avenger who is also a student at PSU. Late one night a stealthy gang of avenging dykes crept onto campus with a giant bucket of chalk and pockets full of stickers, and girrrls, we took that campus by storm. In huge bold words covering four blocks of campus we wrote, "Dykes Kick Back Harder," "Our fuse is short, our shit list is long," "Kick a Bigot Anywhere," and more. We stickered lampposts, bike ramps, anything with a flat surface. And the following morning the students and administration of PSU couldn't help but notice. We had the place covered!!! The following day, the college newspaper printed a front page story and there were two weeks of responding letters after that. As a result of our zap, the college president appointed a lesbian and gay task force to address issues of safety to queers on campus.

Yes, the Lesbian Avengers recruit: actively, passionately and with great enthusiasm! Way back last August when the Portland chapter was just getting started, we heard news of a fiercely anti-queer computer BBS called the Gay Agenda Resistance. GAR warned its members of the existence of the

Avengers, calling us "female homosexual terrorists" and asking its henchmen to collect information on members of the Portland Avengers. Undaunted, the Lesbian Avengers carried on, and in fact took some of GAR's homophobic blatherings to heart. GAR wrote that these "terrorists" are "spreading their tentacles across the country" and indeed, dear octopussies, we are.

Feeling a little bit isolated up here in the Pacific Northwest, the Portland Avengers decided to do some active recruiting. Our first trip was to Seattle, which at the time had several active dyke groups but no Avenger chapter. We figured, hell, get a bunch of Avengeresque dykes in a room together and something exciting is bound to happen. With not really much help from us (the car broke down on the way from Portland and we were an hour late for the meeting), the Seattle chapter was birthed. Hooray!

On April 9th, seven members of the Portland Avengers recruiting girl gang took a road-trip! After driving north (and declaring our yogurt at the border,) we entered British Columbia.

We were guests of the Vancouver Lesbian Connection, one of the only government funded lesbian centers in North America. The inaugural Lesbian Avengers meeting was attended by around twenty beautiful enthusiastic DYKES. We watched "Lesbian Avengers Eat Fire Too," discussed how to start up a chapter and brainstormed about local issues to rally around.

We left the meeting all fired-up and were

Page 4
Activism

taken on a whirlwind tour of the local nightlife; attending a dragshow, dancing at the Lotus and sampling some fine Canadian micro-brew. Driving home we left stickers and new friends.

You go GIRRRLZ!

Welcome to the Lesbian Avengers

We highly recommend these recruiting trips! We get to meet fine, fine women, connect with new and exciting dyke activists, and eventually do some interstate and intercountry actions. Up next? How 'bout a Northwest Regional Lesbian Avenger boot camp? Sort of a mini-Michigan music fest with fire-eating workshops, safe sex demos, billboard defacement discussions, and of course lots of dancing and cavorting.

If you hear of or know of any other Avenger chapters in your area, have them call the New York Lesbian Avenger hotline with the names, addresses and phone numbers of contact people. (212) 967-7711 ext. 3204

Once upon a time, a Portland dyke had a place to go when she had a hankering to pull on her shitkickers and do a little two-steppin'. The Eastside bar was a popular hangout for

the queer country-western set, but it seemed changes were afoot. One Saturday night, when Portland Avengers were pestering straight women to dance at a Queer club suffering a het takeover (that's a whole other story), we ran into a dyke who had just come from the Eastside. The old stomping ground had undergone a bit of a transformation. It was, in fact, so huge a change, our dyke friend was not allowed in without a male escort. What the fuck?! We're dykes, we can go wherever we want to! Dooley's, as the new incarnation is called, had become a strip club that catered to straight men, and lesbians were clearly no longer welcome.

The following weekend a few Avengers decided to check things out for ourselves. We sauntered in, took front row seats at the stage, and waited just a few seconds before the owner, O'Dell Jones, came out to hassle us. We bantered back and forth about our right to be in his club, but when it became apparent that the dancers were on our side and that we were in no hurry to leave, he threatened to have us arrested for trespassing and kicked us out. One dancer then marched up to him and said, "I'm a lesbian, and if this is the way things are going to be around here, I'm taking my clothes and leaving." And she did. We applauded her heartily. The next day we found out that two other dancers had stood up for us and were fired because they "had opinions." This guy O'Dell, he is such an Asshole.

Two weeks later we returned to Dooley's with some 25 Avengers, and were promptly and unceremoniously barred from the club. O'Dell, who isn't particularly sharp, hadn't yet figured out that he was breaking both the state public accommodations code for gender discrimination and the Portland city code for sexual orientation discrimination. Two Avengers managed to talk their way into the club with a couple of borrowed male "escorts." The whole time we were inside, O'Dell followed and harassed us. When we went up to the bar to order beers, we were told

to leave because we were not Glued to our Escorts; can't have wild lesbians running around wreaking havoc, now, can we? The big brave piggy-eyed bar owner and his beer belly escorted us personally to the door.

Members of the Lesbian Avengers have filed complaints both with the Bureau of Labor and Industries (pending) and the Oregon Liquor Control Commission (his license is up for review next month). O'Dell seems threatened enough by a pack of plucky gals to have fabricated some amusing stories about the whole situation. Here are some quotes from his letter to the OLCC. O'Dell Jones was "concerned about a group called the Lesbian Avengers who were trying to disrupt his business. About 50 persons from this group forced their way into the premises on Saturday night, January 29, 1994. They trashed the restroom, put up stickers, slashed his car's tires and dumped garbage in his parking lot. He had to call the police to have them removed." Well, we only wish we were that unruly, but we were in fact fairly contained in our behavior that evening, and have the press and cops to vouch for us.

This just in: a Portland lesbian suing O'Dell Jones for sexual orientation discrimination to the sweet tune of 2.2 million dollars. We don't know her, but we adore and worship her. You go, girl!

Recent Portland news:

We dyke lovemongers of the fair Rose City have been making appearances all over the place, from radio interviews to coalition-building conferences to the "Lesbianism" segment of a Women's Studies 101 class at PSU. Lesbian Avengers of Portland left our mark all over downtown on Mother's Day. Sweetly slipping into ritzy restaurants and sidling up to brunching moms, we presented our Mother's Day cards. The ever-so-popular Hershey's kisses were glued to our greetings, and the moms, for the most part, were charmed and delighted by our gesture. One more political card talked about remembering lesbian moms and the

Page 5

custody battles they face; the other, we quote in full because we just love it so much:

"If you happen to be the mother of a queer child - Congratulations! While, at times, this situation may feel like a burden or conflict, we'd like to remind you of the possibilities of this relationship. Your child has shown courage and love in their disclosure to you and now you can take the opportunity to respond with equal bravery and love. We'd like to remind you on this Mother's Day that bonds between mothers and their children can be strengthened rather than diminished through acceptance and celebration. Happy Mother's Day from your different daughters. Love, the Lesbian Avengers."

Ain't that sweet? We thought so. We also hung two banners in downtown Portland that said, "Don't Assume Your Mom is Straight" and "Dykes are Moms, Too." Yes, we had a grand time and the response was great, too. One quote for the archives: upon receiving her Mother's Day card, one nice elderly woman said, "Oh, thank you! What's a dyke?" "A dyke is a lesbian," I responded. "Oh," she beamed, "thank you, doll!"

East Lansing, MI

This year, for the first time ever, Michigan State University Spartans and East Lansing High School Trojans combined efforts to produce a homecoming parade. We thought to ourselves, "Hey! It'll be a first for us, as well!" On Friday, October 22, 1993, the Avengers sneaked our bomb float into the parade lineup. We masked our intentions with a puny

sign that read, "Bomb the Hawkeyes!" (MSU's homecoming adversaries). Little did the parade judges know that on the flip side of that meager sign was one our Avenger cue cards: "1 in 10 MSU Women is a LESBIAN!" When asked by a judge, whom we later discovered to be an E. Lansing cop, whether or not our float would jeopardize the spirit of the parade, the driver of the float responded with, "Not at all, sir. We'd just like it to be a surprise!" Her misleading cherubic grin got us into the lineup. When the parade moved from Hannah Middle School parking lot to Abbott Road, we unrolled our Lesbian Avenger banners, blared our Lesbian hit tunes, distributed press releases, and unzipped our jackets to reveal our more dapper than ever Avenger T-shirts. The Avenger inside our painstakingly constructed bomb (She wore a fuse hat to finish off the costume!) began FLAUNTING our cue cards to bystanders. They included:

"We dig Lesbian Spartans and Lesbian Trojans," a list of FAMOUS DYKES FROM HISTORY, and... (This is the card we flashed when passing the viewing stand in front of city hall, where big whig city and university officials were seated, for what they thought was going to be a parade like any other.) "LESBIANS PAY TUITION!"

We crowned our very own DYKE HOMECOMING QUEEN (who agreed to camp it up and boasted some very large hair throughout the festivities), passed out recruiting handbills (with chocolate kisses glued to them), distributed fact sheets to onlookers, and generally had more fun than even we had bargained for. We were cheered, adored, and even encouraged by the crowd! We have the whole wacky and outrageous escapade on video tape and are willing to sell it for the fundraising price of $15.00.

Also on this video is the first ever AVENGER AERIAL BANNER.

We could not be stopped after the parade, and on the NEXT day, the Saturday of MSU's homecoming game, we surprised and delighted Spartan fans with a banner flying behind a plane that read, "THE LESBIAN AVENGERS ARE HERE!" and which gave our Action line phone number. Two Avengers interviewed and videotaped strangers about their reactions. One woman thought the Lesbian Avengers were a new wave punk band! These interviews, a half hour of Avenger fun, are also on the video tape which is now available to you at the amazing fundraising price of $15.00!

Editors Prize: Most Inspiring Action

The Lansing Avengers tried some great fundraising ideas this winter. At the beginning of December, we held an All-you-can-eat Lesbian Pancake Breakfast at a community center in the area, featuring Lesbian Avengers in pj's doing the serving. The food, coffee, and door-prizes were donated by area businesses, so not only did we make a profit, but many lesbian-friendly businesses got free publicity.

On New Year's Eve, we held a dance bash at a warehouse recently purchased by a lesbian in our community. The Avengers donated time to cleaning and construction, and we had a sound system to rock the house. We made money on cover charges and selling t-shirts and calendars. We had a toast at midnight; and then another at 12:15 to celebrate "Dyke-Time" New Year!

The Lansing Avengers wished all a Happy Dyke Valentine's Day. Around twenty womyn sang such classics as "My Girl", "Why Do Fools

Page 6

Confrontation

Fall in Love" and "You Are My Sunshine". The first two songs were made even more classic when we changed the verses to "My Dyke" and "Why Do Dykes Fall in Love". We sang to six sororities on one local street. We were told to stop when two police cars claimed we were violating a noise ordinance. We then proceeded back to the home of some of the womyn and serenaded that house. It was truly a Happy Dyke Valentine's Day!

Minneapolis, MN

We got started on International Women's Day this year when a bunch of dykes potlucked and talked about starting a Minneapolis-based lesbian direct action group. A number of such groups have existed in the Twin Cities before, but a few of the women had seen what had been happening with the Avengers in New York and we figured that the kind of work we wanted to do -- action, not theory; proactive, not reactive; and frisky as all get-out -- fit right in with the Lesbian Avenger credo. To celebrate our inception we decorated a local navy billboard, which caper not only made the local press but Pacifica radio nationally and The Advocate, too. This could be fun, we thought.

For the next month or so we continued to redecorate local billboards, crusading against militarism and misogyny and bucking up the spirits of local lesbians. We tabled at the Twin Cities' Lesbian/Gay film fest and at a national queer studies conference held here, and generally got the word out about our existence in order to build interest in going to the March on Washington. Around a

dozen or more Mpls Avengers converged on Washington (with many more on-the-spot recruits). You may remember us at the Dyke March as the gals with the cool lavender and aqua bomb logo flags, the Lesbians Taste Good suckers (we ran out of the 1,000 we made before we got half way to the white house), and the DON'T SUCK UP, SUCK US banner.

Needless to say, the Dyke March got a lot of Twin Cities dykes interested in direct action in general and the Lesbian Avengers in particular. We tried to get more local women interested by marching in the Mpls May Day parade, passing out still more suckers (LICK HOMOPHOBIA), and tabling at the end of the parade. Much of the rest of May was taken up strategizing some sort of response to the upcoming Operation Rescue infestation which was slated for June. We talked with other direct action groups, and in loose coalition with them defaced and revised numerous local O.R.-sponsored billboards (one of which sported a "heartbeat at 10 weeks" caption under a sorry-ass looking fetus). One highlight of this preliminary O.R. "welcome" was our wheat pasting huge banners on the side of the very church were all the local religious fright organizing has been headquartered. Our favorite banner slogan: SPANK THE LAMBS. Those who didn't know of the Lambs of Christ organization in these parts were perhaps bamboozled, but those of us into discipline just couldn't resist.

Okay. So, the weekend before the City of Refuge campaign was to begin, the local religious fright organized a so-called "March for Jesus." To which we responded with our own "March for Mary." Along with other direct action people we showed up in various costumes and with various props & signs and generally did as much as we could to rain on their parade. The rest of June was divided between getting back at the O.R. slime which had invaded the area, and organizing for the Twin Cities'

first ever DYKE MARCH AND DYKE BALL.

The event was, in a word, bodacious, as all of you sisters from around the country know from own Dyke marches. The night before Pride we had between 800 and 1,000 raucous, frisky, hell-raising, sign-toting, bustier-wearing, dildo-packing, leather-clad women marching (sans permit, of course) through the streets of Minneapolis -- it was a fabulous turnout, for around these parts. We started the march in a park downtown (okay a commandeered intersection downtown), right about where many hundreds of women were exiting the annual Dyke Night performance. The ladies were thrilled, needless to say. So we hogged up a lane of traffic an moseyed and shouted our way through south Minneapolis, winding up at a space we rigged for our Dyke Ball. Therein we reveled, tabled, boogied and fund-raised, selling T-shirts for $10 and kisses for $1 (maybe we'll raise the price in the future but hell most of us were feeling just plain cheap & easy).

The march and the ball were a raving success; no gal in town had ever seen such a thing happen here, and everyone is looking forward to this becoming one of our most cherished annual events. Of course we marched in the parade the next day, and tabled at the end of the parade, but the night before will live on the most infamy, as most of us found at the march in D.C.

We had a quieter time in July, refueling, and plotting our next moves. One move involved some

long-range planning for work in the local public schools, doing dyke awareness and education in the high schools in fall. Another involved preparing a performance space where dykes could enjoy one another (in any which way) and where we could do more fun(d)-raising. Avenger women worked with other local lesbians to create Vulva Riot, a once-a-month event which started in August and has showcased local dyke performers (comics, dancers, etc.). After the performances has been dancing, poker, film screenings and sauna-ing. With more coaxing, we hope eventually to evolve the evening into a sex club for women, too, since this phenomenon has yet to truly hit the Twin Cities' lesbian population. Proceeds from Vulva Riot go to the performers, the local Lesbian Avengers, and the Women's Cancer Resource Center. At the second Vulva Riot, a woman was assaulted -- i.e. hit in the face, resulting in a broken nose and lacerations -- just outside the building before the event began, since then we have joined up with the nascent local Queer Street Patrol to provide security for women coming to the event.

When his holiness the pope showed up in Denver in August, we marked his arrival with an action in downtown Minneapolis in front of the Federal Building, at which we pontificated (that's one "f" in pontificated), burned the U.S. and papal flags, and at which some of us ate fire. No significant injuries incurred; much curiosity and amazement aroused.

In September we hit the schools, making early morning appearances at four area high schools to raise awareness about

lesbian lives and provide information and resources to teens. With signs, flyers and suckers (hey--if a concept keeps working, keep using it!) we greeted the school-bound youth. One flyer detailed ten ways to stop homophobia, another carried info about local hotlines and support groups. To follow up these actions, we held a forum for open discussion of lesbian needs in high schools; this project will be long-range and ongoing. At the first forum we met with people from the local Queer Youth center and a St. Paul-based school health clinic organization, and shared information with each other and interested high school students on how to start a lesbian support group, how to come out at school, and the like.

We have proof that we made an impact, since at one of the school actions one dude was so moved by us that he was possessed by the urge to fling his baloney sandwich at one Avenger, though some small debate exists about whether it was in fact peanut butter. On the up side, while we got moved off school property by cops one morning, students offered to pass out our flyers inside the school grounds. We also got good coverage in an article from the Minnesota Women's Press, and we heard from people at a local junior high that they were frustrated to be left out: "how come the high school gets Avenging lesbians and we don't?" We are making moves now to rectify that oversight.

In October we held our Halloween March for Rage and Remembrance. That event was a success, with over 75 women coming out to brave the cold, roam the streets of downtown Minneapolis, testify against violence against women, and eat fire. During the last two months of the year things were somewhat quieter. In November we did a speaking gig at the Minneapolis Arts High School in Golden Valley, talking with that school's LGBT youth group about activism and survival (which are mutually

supportive, in our minds).

Our first action in 1994 was a march and speakout against domstic violence, set on January 28, one week from Lorena Bobbit's acquittal on charges of "malicious wounding". We wanted to draw attention to the real issue of rape and domestic violence, and away from the pressing matter of whether John Wayne Bobbit's member was up and running, the news item most media people seemed obsessed about. After a rag-tag group of Avengers and some onlookers assembled at Peavey Plaza, we went to the Government Center and passed out flyers which included stats on domestic violence and rape, and the phone numbers of local battered women's shelters. Though our numbers were small (due in part to nasty weather), we all felt good about the action and felt we were effective - one woman wanted to donate old furniture to a shelter and we connected her to the one closest to her. Later in January two Avengers did another speaking gig for the LGBT youth rap group at Northwest Youth and Family Services in New Brighton, where we made good connections with social service people in touch with issues facing young lesbians in the schools.

In February we celebrated Lesbian Luv with our Travellin' Lesbian Lovemobile. This was a BLAST, and if anyone chanced to see this slogan- and heart-bedecked vehicle cruising the streets of downtown Mpls during rush hour on Valentine's Day, you'll know what we mean. About a dozen hearty Avenger gals cruised around in the back of this truck, hopped out at key intersections, and passed out cards with Hershey's kisses which read: YOU'VE JUST BEEN KISSED... BY A LESBIAN! HAPPY VALENTINE'S DAY FROM THE LESBIAN AVENGERS. After ransacking downtown, the Lovemobile went to Uptown -- horn honking and Avenger flag waving all the while -- where the reception was a bit warmer. Every look of shock, bemusement, disgruntlement, and gleeful appreciation was worth the mild chill

Page 8 Eat Fire

the truckload of dykes withstood.

Our first aniversary party and fun(d)raiser was a raving success: we cleared over $350, threw the best party people had seen in a very long time, garnered mention in the local gay press gossip column, and netted many a date from & for many a lesbian. The kissing booth and slides of lesbian erotica continually showing on the wall were particular faves; after a point women were shoving dollar bills in the shorts of any passing Avenger and smooching them on behalf of the group. We may have made as much money outside of the booth as inside it.

As for other goings on in these parts: on March 14 we gave a warm welcome to every lady's role model, Phyllis Schlafly, when she spoke at a local college about, of all topics, feminism. We staked out the front of the building, chanting, toting signs with her photo (augmented with squirrelly spirals over her eyes) and passing out literature about the Christian Right's despicable agenda. This managed to scare the esteemed guest speaker into taking the back entrance into the auditorium. After some of us snuck into the place (who's gonna pay to hear this woman speak?!), we unfurled a fine banner which read: ANTI-WOMAN / ANTI-DYKE / PHYLLIS SCHLAFLY TAKE A HIKE. Apparently, this coupled with our consistent boos and other disruptive behavior (some situations just don't inspire reasoned discourse) was more action than Augsburg college had seen in a long while, because the next edition of the school paper was practically a special issue dedicated to the "controversy" we apparently generated at the event.

As for our work between now

and Stonewall: mostly we'll be getting the work out locally about both the caravan and about Camp Sister Spirit and the local support Committee. On May 1st Mpls' progressive community has a fabulous and huge May Day Parade, which marked our first local public appearance here last year. This year we plan to haul a big fat bomb prop and throw out suckers (old idea, perhaps but it's beginning to be one of our best trademark gimmicks). The parade's theme this year is "Seeds are Awesome Vessels of Pover" (so it's a bit touchie feelie). Our suckers will bear the flag: LESBIANS ARE AWESOME VESSELS OF POWER, and our bomb will read: SEEDY LESBIANS ARE AWESOME. At the end of the parade we will table, as per last year, and recruit caravan riders for the extravaganza of activism in NY.

San Francisco, CA

On Saturday, January 15, the San Francisco Chapter of the Lesbian Avengers took over the corner of Virginia and Shattuck in Berkeley for a highly successful Bobbitt-cue and wienie roast. The purpose of this urban barbecue was to highlight the state of Virginia's "family values." The Lesbian Avengers were surrounded by posters proclaiming such messages as: "Virginia is for rapists!," and they passed out flyers which stated that "Lesbian Avengers know that Rape is All In The Family, Do you?" and included paragraphs of information and statistics on battering of immigrant women, on marital rape and on the trials of Lorena Bobbit and Sharon Bottoms, who lost her child due to her lesbian household. Lesbian Avengers were quick to point out that Sharon Bottoms' son had been removed from a loving lesbian household and placed in a home where Sharon had been molested as a child.

The Bobbitt-cue entailed roasting the penises of John Wayne Bobbitt

60

Editors' congrats

and Judge Buford Parsons (the judge in the Bottoms case), which were then offered to passers-by, including a member of the Berkeley police force, who was ensuring that the barbecue was indeed just a prop. Lesbian Avengers Adrienne Forstner-Barthell and Sabrina Mazzoni performed street-theater with the re-enactment of the surgery which reunited John Wayne and his penis. The Bobbitt-cue was well-received by the Berkeley natives and enjoyed heavy press coverage both in and out of the queer community. This action not only transmitted the Avengers attitude towards the justice system; it also recruited more Lesbian Avengers!

Prior to the public forum/meeting of the Human Rights Commission held August 12, the Network Against War and Fascism staged a demonstration outside the meeting place to "Dump Lumpkin," referring to the demand for the ouster from HRC of the Baptist minister who has called homosexuality an abomination of God.

The anti-Reverend rally began with a marching picket line headed up by the Sisters of Merrrcy, a group of gay men, chanting "2-4-6-8, separate church and state!" ... The Sisters of Merrrcy were joined by members of the Lesbian Avengers, who marked the occasion with new drag and a

new alias, "Ladies in Support [NOT] of Lumpkin." From a distance, members looked like fundamentalist church ladies, but up close, their unshaven legs and queer activist demeanor revealed their true identity.

The Lesbian Avengers added a humorous touch to the demonstration with frumpy, dowdy drag as uninformed, dumpy Lumpkin supporters. Among the placard messages: "What's all this fuss about Pumpkins?", "Frank Jordan: One Neat Mayor," and "Nice Girls Sleep with their Bibles." The reverse side of their signs displayed the Lesbian Avengers logo, a big, black bomb. "The fact that Jordan has defended Rev. Lumpkin makes a mockery of the HRC," said Rachel Cooke of the Avengers and the Harvey Milk Club. "We decided to make an ironic statement and take this issue to the other extreme as little Bible-loving ladies supporting Lumpkin's views," (I can't read the rest).

The Lesbian Avengers targeted Twin Peaks Tavern for a non-hostile action that would visibly highlight the overt and subtle misogyny existing in the Castro. We had notified the owner of our action and our intent (non-hostile) earlier in the week. Our primary motivation was to alert the men in the Castro that we were fed up with the misogyny and were finally going to do something about it.

There is an abundance of places on the Castro where women are subject to some form of discrimination based on sex (misogyny), whether it be from the owners/managers of the business or from their patrons. Equal space for women-oriented women in the

Castro does not necessitate creating another space: it can also be accomplished by reclaiming places that exist.

We were quite surprised by the reaction of the owners and the patrons. First of all, the bartenders and waitresses had apparently been warned to expect "200 screaming radical women," and were very anxious to inform us that they really did not have the space nor the serving capabilities. Once reassured that that was not our intent, they were very pleasant and efficient, and many of us commented on how Twin Peaks would be a wonderful place simply to come to regularly. Women showed up early in the evening to occupy the comfortable and visible window seats, then the Thesbian Avengers, a group that sprang up from dramatically inclined Lesbian Avengers, directed by member Reilly, conducted an abbreviated version of a romantic lesbian dinner outside the bar. While feeding each other morsels most delectably (the wind precluded candlelight), the numbers of women in the bar increased to between sixty and seventy. Flyers were handed out to explain what was being done, and quite a few of the patrons were also supportive of our presence and of the motivation behind the action and the explanation of the action.

Others were quite confrontational, feeling that "at this rate, there'll be no place left for men in the Castro." We confronted these men about the reality of the Castro versus their impression of it. We are tired of having only one bar (the Café), one clothing store, one bookstore, and a few other businesses where lesbian, bisexual and transgender women can feel comfortable entertaining and transacting business in the Castro. We were also quite surprised to learn that after the Oct. 1 action, the owner of the Twin Peaks Tavern claimed to have thrown us out. In fact, we enjoyed ourselves thoroughly and finally left late in the evening to pursue other activities.

The Lesbian Avengers realize

that Castro men do not necessarily represent the attitude of gay men in general. However, we feel it grievous that the center of homosexual culture in San Francisco cannot welcome or support its lesbian sisters. And we plan to change this present reality.

Hundreds of activists and supporters will take to the streets on Saturday, Oct. 23 to remember Joan Baker, a 26-year-old lesbian who succumbed to AIDS on Sept. 3 after a six-year struggle. Organizers of the march, which is sponsored by a coalition of groups including the Lesbian Avengers, ACT UP San Francisco, ACT UP Golden Gate, Lyon-Martin Women's Health Services and Women Organized to Respond to Life-Threatening Diseases, hope to shatter the myth that women who have sex with women can't contract HIV/AIDS, a notion they say is widespread among lesbian and bisexual women.

The Lesbian Avengers of San Francisco are currently planning an action entitled "The Castro Goes on the Rag," to protest the problem of misogyny in the Castro, fight dyke invisibility in the Castro and to encourage women to patronize women-owned, women oriented spaces. We plan to put on several short skits, re-enacting actual instances of women being harassed or discriminated against in the Castro, with a few fictional, entertaining and slightly crude twists of our own. We will also distribute flyers about the problem of misogyny in the Castro. The action will end with a march down Castro Street to the Whiptail Lizard Lounge, a women-only space in the Castro. (Women from Whiptail will be involved in the action itself as well.) The action will focus around the theme of maxi pads. The misogynist male protagonists of the street theatre will be "padded" as penance for their behavior and we will wear maxi pads as identifying badges throughout the action. Why maxi pads? Because we can't miss the chance to make the boys squirm a bit. The action is still very much in

the planning stage, so we may make significant changes in it before it actually takes place.

We, the Lesbian Avengers of San Francisco, have voted to change our mission statement to reflect the lifestyles, diversity and contributions of the women that make up our group. The new statement reads as follows:

The Lesbian Avengers is a direct action group of lesbian, bisexual, and transgendered women focused on issues vital to our survival and visibility.

The Lesbian Avengers of San Francisco, renowned for our sartorial excesses, are sporting fancy new "duds" for the upcoming hot summer season. Dianne DiMassa has created, along with a group of Avengers, a T-shirt depicting Hothead Paisan wreaking havoc on the streets of San Francisco with her "girl gang" the Lesbian Avengers. Anyone interested in purchasing this unique and creative design should contact the S.F. Lesbian Avenger hotline to place an order. They are selling quickly so give us a call soon if you want one for Stonewall 1994. Hotline # (415) ▓▓▓▓▓

Atlanta, GA

Our first action was on Valentine's Day, 1993. We went to Lenox Mall (the center of conspicuous consumption in Atlanta) to pass out flowers and Valentines that included chocolate kisses and sayings such as: Lesbians make better lovers/kissers, Someone you love is a lesbian, Kiss a lesbian today, etc. We signed them Love, the Lesbian Avengers.

That action was fairly successful until we got kicked out of the mall, but we did not get much press coverage for it. There were about 15 of us there.

We then concentrated on the debate over the military ban, since we live in the state that elected Sam Nunn to office. We formed a splinter group - Nuns with guns for Nunn - to interpret Nunn's statements about gays in the military; we concluded that Nunn really wanted an all lesbian military. A group of us (5) went to the lift the ban rally (April 4) and set up a table where we recruited and passed out our mission statements. Since we wore makeshift veils, we did attract media attention; one station actually gave us an interview on the news.

Next, we threw a party for fundraising. We set up several

rooms with video equipment so that we could show different kinds of lesbian films in each rooms: Classics, Wannabe lesbian movies, pornography (by far the most successful), Horror/Vampire, Psychokiller, etc. This party was not as successful as we had hoped, but we did manage to break even.

After the March on Washington, we began to organize a Dyke March in Atlanta, on the day before Pride. It wasn't our idea, but those

who began organizing it called us in at the beginning. We had a major debate about whether we should have a permit or not, with those who originally planned it not wanting one, and most Avengers agreeing, but we were overpowered by the queers in suits who insisted.

Before this took place, however, a group of five of us went to Tampa on June 10 to participate in the action organized by Act Up Tampa and Lesbian Avengers St. Petersburg. On June 11 we did a Candlelight Vigil at the home of Dee DeBerry to protest police inaction in response to the death threats she had received and the firebombing of her house. There was a speak out, and some New York Avengers ate fire as part of this demonstration. The next day, we formed a procession to slowly cross the Gandy Bridge from St. Petersburg to Tampa, slowing down traffic and holding up signs. In Tampa, we protested at City Hall, mainly by legal picket, until the mayor came out to speak to us. Lots of press coverage for these events.

Back to the dyke march in Atlanta, on June 26, 1800-2000 lesbians showed up for the dyke march, which was really fun. The city had given us one lane of traffic, but we took 3 for most of the march. Maria Helena Dolan spoke after the march and some Atlanta Avengers ate fire.

At Gay Pride the next day, we had some conflict with security, who were very upset that some Avengers took their shirts off. We were repeatedly hassled and threatened with arrest, although the police didn't seem to care at all.

A few days later, on June 30, Mayor Maynard Jackson vetoed the domestic partnership legislation passed by Atlanta City Council. We protested outside City Hall at 5:00 that evening and for

Page 11

several days later the protests continued. On July 1, Dykes and Faggots Bash Back organized a protest at Maynard Jackson's home, which made him extremely angry. We also attended, as did Act/Up and Queer Nation. GAPAC organized a lunch-in on Friday July 2, where we went to City Hall and ate lunch and chanted in normal tones of voice at noon. That evening, we had an affinity group meeting for street activists - Lesbian Avengers, Act/Up, Queer Nation and Dykes and Faggots Bash Back. Saturday night the Avengers held a demo in Virginia Highlands, an area composed of restaurants and bars that's very popular with the yuppie liberal crowd. We were going to stand on a very popular intersection and eat fire, but so many people (40 - not all avengers - affinity group people as well) showed up that we ended up also marching up and down the street. We received a great deal of press for this action, which I think

was the best of the weekend. On Sunday, July 4, we went to Piedmont Park where the Peachtree Road Race ended (a major event for the weekend) to have a large protest - about 100 people. Our slogan was Civil Rights or Civil War. We made people very angry, because they felt we shouldn't be interfering with their sporting event.

The next night, Monday July 5, three Avengers almost got arrested for wheat pasting flyers and Lesbian Avenger stickers on City Hall. Although there were far more police than activists, we were slippery with wheat paste and escaped. On Tuesday, we attended the City Council meeting, where Councilwoman Mary Davis attempted to override the veto. Although she failed, she did reintroduce Domestic Partnership legislation which will be voted on soon. It is expected to pass, and hopefully Mayor Jackson will sign it this time around. (He did.)

Back to the issue of the military - on July 31 Lesbian Avengers and Dykes and Faggots Bash Back co-sponsored a demonstration at the Armed Forces Recruiting Station. Our chant - I don't know but I've been told (I don't know but I've been told) Sam Nunn is a homophobe (Sam Nunn is a homophobe) Sound Off Sam Nunn Sound Off Fuck You Sound Off Sam Nunn Fuck You! We were planning to enlist and tie up their personnel with questions about what exactly Don't Ask Don't Tell means, but the center closed at noon that day. We had about 60 people show up and okay press coverage.

In August, we had Cobb County to contend with (as if the mayor and Nunn weren't enough). Cobb County (an area north of here composed mostly of upper middle class, white and white-bread suburbs, extremely conservative) recently passed an ordinance in response to a play that

toon by Stephanie Mulligan

LOOK, I KNOW YOUR DRAG QUEEN FRIEND MEANS WELL, BUT NEXT TIME LET'S DESIGN OUR OWN CAPES.

variety lesbian, but a "mean, militant, activist lesbian," dressed in large flowered hats and flowing dresses or overalls and straw hats. We carried signs with appropriate slogans such as "Helms is too mulch!" and "Compost Helms!" Like all our demonstrations, this action was covered enthusiastically by local television stations.

On September 11, the Avengers together with the North Carolina Veterans Coalition protested against Congress's action in codifying the military ban. Masked veterans chanted, "Don't Ask, Don't Tell, Don't Love," and in an alternative recruiting station flanked by rainbow flags, the crowd swore to uphold the Pride Pledge, promising to defend the constitution against hate mongers.

The Durham Avengers are celebrating their second year of action by planning a "Stroll-In" near Mother's Day to demand protection for lesbian child custody and adoption rights. We borrowed the idea from Virginia women who demonstrated for Sharon Bottoms.

We have had success fundraising with our own version of the Lesbian Avenger T-shirts: purple bombs on black, very stylish. We have also shown the "Gay Rights, Special Rights" video to inform women of the right-wing attacks on us, as well as other related films and responses to the films. Mandy Carter of HRCF helped lead the discussion, focusing on the necessity to build coalitions with African-Americans to fight the right-wing attack.

Undercover Lesbian Avengers have also been active in trying to get our local city council to pass an ordinance prohibiting discrimination on the basis of sexual orientation. As of today (April 4, 1994), the City Council passed the ordinance, but the State Legislature must provide enforcement power, which is dubious in Jesse Helm's state.

Last fall we demonstrated again for

Page 13

gays and lesbians in the military, in coalition with with the North Carolina gay and lesbian veterans group. Our colorful rally, complete with rainbow flags, masked veterans, and a mock recruiting station, got good press and TV coverage.

In general we are trying to increase lesbian visibility and power by educating, building coalitions, demonstrating, and focusing on both local and national issues.

New Orleans, LA

The NOLA Lesbian Avengers have been busy being radical and firing up The Big Easy as much as possible. In August, we sponsored a "Back-to-School Shopping Spree" at the biggest mall in the most conservative 'burb of the city we could find. Needless to say, we got a few stares, not to mention the police wanna-be's breathing down our necks, but all in all, it was fun and a good visibility action. We all wore our fashionable Lesbian Avenger T-shirts, passed out

balloons to the little kiddies (until those pretend cops made us stop, that is!), and even made some purchases from Macy's lingerie department.

Last month, we were joined by our Lesbian Avenger sisters from Austin, Texas in participating in the Ocean Springs, Mississippi March. You may have hears the story ...two local gay men and a lesbian working with some of the members of the Lesbian and Gay community were holding meetings to discuss opening a Community Center on the Gulf Coast, for which they met rabid opposition from the local religious right. Knowing that our kind stick together, a distress call was issued, and around 500 queers hailing from Texas to Kentucky joined them in their parade and rally. The police were in abundance, but no arrests were made, and in fact, the main problems the local law enforcement seemed to have came from the straight folk. The Lesbian Avengers got a lot of news coverage, (no doubt due to our beauty and culture, and not our radical lesbian gear) and our banner flew proudly the entire day, (incidentally, the Gulf Coast now has a Lesbian and Gay Community Center, so the day was a

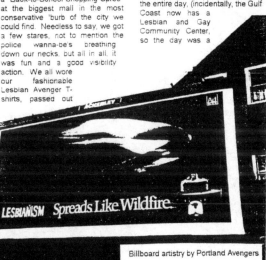

LESBIANISM Spreads Like Wildfire.

Billboard artistry by Portland Avengers

success.)

For anyone who has received the October 19, 1993 edition of The Advocate, check out page five, where the New Orleans Lesbian Avengers received coverage. Oh, and did we mention that NOLA is running for Mayor in our fair city?

Upcoming events include fundraisers entitled "I Love a Gal in Uniform" and "Lesbo-A-Go-Go!" We will have news on these and other Avenger events next time...but for now, please always remember and never forget...

WE ARE WATCHING YOU

 Denver, CO

The Colorado Lesbian Avengers take to the road for their first in-state FREEDOM RIDE, September 25th, 1993.

The day of the first Lesbian Avenger's Freedom Ride(s) began early on a crisp, Denver Sept. morning. The lovely christian women or really the Lesbian Avengers disguised as bible-belt housewives, congregated at around 8:30 a.m. at Denver's Community Center. Their lesbian spirits glowing and their lesbian hearts pounding, most likely from the 2-3 cups of java, but nonetheless, they packed up the protest equipment in their custom, un-pope mobile and headed south to the once magically beautiful home of Pike's Peak: Colorado Springs.

First, a little background on the group, Focus on the Family, and why an action was declared by the CO Avengers to go to the campus dedication taking place in CO Springs. F.O.F. ministry is a non-profit corporation, which on Sat., Sept.

25th, was having a dedication ceremony for their new 30 million $ headquarters, a building on their 47 acre-plot campus. Facts provided by lesbian writer, Cathy Deitech of Denver, reveal that the empire of F.O.F.'s ministry was founded in 1977 by Dr. Jones Dobson and in 1992 marshaled support and revenues of nearly 80 million dollars, a staff of 1,200 and programming which broadcast 13,000 times per week on more than 4,000 radio facilities worldwide. At least 8,000.00 of the group's 80 million 1992 budget was spent on the CO law that legalized discrimination against gays and lesbians.

Activists from Boulder, Denver, Co. Springs, and Manitou Springs mailed in for their dedication tickets being offered by the F.O.F. for their ceremony. Our presence was a necessity and since this dedication was open to the public; the Lesbian

Avengers complete w/tickets and dressed as proper Christians, just wanted to be VISIBLE -- by stripping to our Avenger Shirts! by 11:00 a.m., the Avengers arrived in the Springs by a car convoy. Two Boulder avengers, Claire Drucker and Julie Glamber, drove down earlier and because of the size of the campus, we were unable to locate them as we met with a group of Springs Activists, including Avenger, Jocelyn Sandberg. Shocked by the size of the campus and by the number of cars bumper to bumper waiting to park for this ceremony as the U.S. Air Force provided parachuters and a choir; we waited outside the campus to gather other protesters. As we were setting up the protest camp, Avengers Claire, Juliet (?) and Theresa of Manitou Springs, entered the campus just in time for the national anthem. They joined the 13,000 Christians, but they proudly stood backward facing their enemy and symbolically showing "UNITED we DO NOT Stand." When the Co. Springs police caught a glimpse of these deviant, three women, they intimidated the Avengers to sit on a nearby bench or be arrested. As a cry for justice, the three disrobed to their LA-shirts and began to chant, "we are a part of your family," and "Jesus loves us, too." The police immediately reacted to the 3 vocal lesbians and with no hesitation they were arrested and charged with disorderly conduct.

Back at the protest camp, Avengers Chris Greenwald, Terry Schleder, Leal Algiene, Jocelyn Sanberg, and Angela Santoro with the help of our X-MEN (the Lesbian Avenger's ladies auxiliary), brainstormed their plan of action. In the process of placing protest signs up around our location, two police cars pulled up. Co. Spring's Police Dept.'s Tommy Thompson approached us to let us know that if we have been targeted as

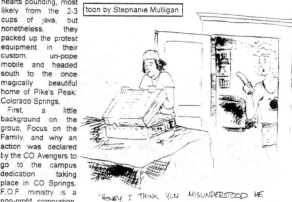

'toon by Stephanie Mulligan

"HONEY, I THINK YOU MISUNDERSTOOD ME WHEN I ASKED YOU TO START PACKING!"

trespassers and we will be arrested if we tried to go inside the campus -- even though we had tickets. Angered by this threat, I asked if the F.O.F. requested that the police stop the lesbian and gay people from entering the campus and he replied, "yes." It was no big surprise, but it was a clear act of discrimination against our much needed civil rights. Imagine if this officer said something like, "The F.O.F. will not allow Native American people on its campus." The bias was clear so we decided to just strip down to our true colors complete with LA shirts to walk the sidewalk in a peaceful, yet vocally loud protest. Jocelyn Sandberg took to the parking lots placing fact sheets on every car, which stated lesbians are a part of your family and listed famous, historical lesbian figures. Walking towards the campus, our group of about 15 people was followed by 4 cop cars and when we reached the corner across from the campus, another group of police officers approached us. It was like being back in high school when the meathead, heterosexual boys would bully the weaker kids for their territory in the school hallway. These cops were protecting the F.O.F.'s territory. An officer in front warned us if we crossed the street to be on the campus sidewalk, arrest would follow and in an outrage, we demanded to be able to walk on the PUBLIC sidewalk around the campus. The officer responded by saying, "I need to see your I.D.'s" Well, no one had their I.D.'s handy and at that point the media swarmed us and 3 CO. Spring's activists, who had witnessed the LA's arrest, had joined our group. It became a feeding frenzy for the media representing CO Springs, Denver, and the BBC. For the media we pressed several major issues -- it was an outpouring of our civil rights being stripped and threaten by the CO Spring's officers. The ACLU has been alerted since the day of this event and there is concern on their part to take legal retaliation. According to Terry Schleder, who alerted the ACLU, "The police were using

Page 15

Get Even

scare tactics to prohibit our free speech and discriminate against us. This is unconstitutional. They're no better than the bigots who supported the event."

I shall keep you updated and informed as Claire, Juliet, and Theresa face their court date, Mon. Oct. 25th, which is the same day Terry and Angela go to court for handcuffing ourselves to the Governor's mansion.

 New York, NY

On 10/13/93 we zapped Sam Nunn when he came to speak at the YW & YMHA (92nd St) in NYC. There were 15 of us (with 3 additional support people). We dressed as a "color guard" like in H.S. -- pleated short skirts, knee socks and our Avenger T-shirts. We had an Avenger Flag -- silver lame with purple chiffon stripes and an avenger bomb in the center and when he started to speak, Dana stood up and said, facing the audience: "Wait, We forgot to say the pledge!" which was our cue to all line up in the aisle and start saying our pledge of allegiance: "I pledge allegiance to the dykes and fags of the United States of America, and to the principles upon which they stand, one community, questioning Nunn, indivisible, fighting for liberty and justice for all." We also had paper planes with the Avenger logo on the tail fins and with the statement: "Sam Nunn is incompatible with lesbian liberation" printed on the paper. We flew these through the auditorium. Now, as we started the pledge we were attacked by the security guards -- however, as they were physically bashing us we kept saying the pledge being dragged and smashed out of the auditorium -- we did fly our planes.

the only thing we didn't get to do was to march around the auditorium and hum "Taps" on our way out. Then we ended up in a brawl (a dyke riot) in the hallway with these piggy guards and since then have been mounting a campaign against the Y -- demanding that they make an apology; that they fire the guards and the executive director who was there and did nothing; that they pay for the medical costs and for a pair of glasses that they broke; and that they institute anti-racists, anti-homophobia and anti-sexism training for all of their staff. The fact is that they only attacked the women and the one man of color who was involved in the ACT UP action which followed ours. They

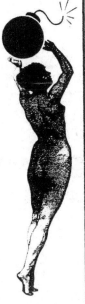

gently asked the white men to leave the auditorium and even brought a bag one of them had left inside out to them. We have been petitioning in front of the Y, got photos from the video we have of the whole thing, of the director and some of the guards, and made posters which say across their faces: the Y's lesbian bashers" and have gotten several well-known speakers to make statements from the stage. We've demanded a meeting with the Chair of their board -- it continues.

8/13/93 We did a visibility action – a sunset cruise on the Staten Island Ferry where we played spin the bottle.

10/23/93 We did a visibility action on the L train -- rode it together and handed out flyers about anti-lesbian violence -- some lesbians were bashed on that train and a gay man was knifed right after he left that station. We had participated the week before in an anti-violence March in that neighborhood but wanted to do something specifically Lesbian and more direct.

10/30-11/2 We are again doing an encampment for the Halloween Weekend. We built another shrine and have set it up and will be having Avengers there 24 hour a day until election day to bring attention to anti-lesbian and gay initiatives all over the country. As the Halloween March passes by that site we are going to have a group of witches eat fire.

Austin, TX

Blaring horns and paper airplanes interrupted business during the last day of the legislative session May 31, as people opposed to the state's sodomy law staged a protest in the gallery of the Texas house.

Ten members of the Austin chapter of Lesbian Avengers spread out throughout the third-floor public gallery overlooking the House chamber and began blowing horns and unfurling banners reading, "Legalize Lesbian Sex" and "Homophobia Stinks." The protesters also tossed paper airplanes on to the House floor that said, "Homophobia Stinks."

Lawmakers briefly halted consideration of a number of resolutions during the protest, then resumed work. The protesters were escorted from the building by security guards. All 10 were arrested and charged with disrupting a public meeting, a Class B misdemeanor, said

Franklin Cox of the Texas Deparment of Public Safety. One protester shouted, "Repeal the sodomy law," as he (?) was handcuffed and driven away in a police car.

The Senate earlier this session had voted to remove from state law a statute prohibiting gay sex. The repeal was added to a bill to restructure the state criminal code. But House members insisted that the statute remain in the law to keep same-sex sodomy a crime. An appeal of the current statute is pending before the Texas Supreme Court.

Obviously, lots of fundraising has been going on for the past year. Events have included: a Deneuve magazine-sponsored disco, dyke film night at a local theater, "Send a Dyke to Stonewall' button sales at boys' bars, a lingerie party where Avengers modeled their best underthings to an adoring crowd, and passing the hat while fire eating topless at Girls In The Nose shows.

If all this weren't enough, the

Austin gals have been doing their share of Avenging homophobia as well. In April, the Cedar Park Baptist church put on its Marquee "Don't be deceived: homosexuals commit the most heinous crimes in America." A brave group responded by dumping a 3-foot pile of horse pucky in the church parking lot before Sunday services, and wheat-pasted various flyers that said, "Homophobia Stinks," "Jesus was a homeless hippy who loved everybody, why can't you." "You eat shit, we eat clit," and so forth. The local TV station broadcast the deranged pastor saying homosexuals "feed off the manure of the world."

Another Baptist church lead a petition drive to place a referendum on the May 7 ballot to eliminate health benefits for domestic partners of city employees. Avenging pall-bearers were broadcast live on the local news carrying the coffin of "Jane Doe, who died of Breast Cancer, because she was uninsured," in a funeral procession to the county courthouse on the first day of early voting.

In the past few months, the Austin Avengers have also supported other groups. With OutYouth, they passed out balloons at a high school where the principle would not allow a gay/lesbian student group have a teacher or counselor after school so they could hold meetings, raised over $1000 during a battered women's shelter walk-a-thon, and volunteered to usher at a rape crisis center all-female boxing fundraiser.

Recent wheat pastings have included a "Celebrate Dyke Love" Valentine's Day flyer, and a "Lesbians Come In All Colors" flyer, which featured a photo of some of the women of color in the group.

Santa Cruz, CA

Lesbian Avengers in Santa Cruz; Who Knew? Well, we are hoping that soon the entire

county will have felt our presence and will have at least an inkling of what we are about.

Our small-but-mighty group is always on the lookout for a few good women. Fresh ideas are always needed to keep our actions energetic, humorous and fun. If shaking things up a little bit while attacking homophobia in our community and promoting lesbian visability is your idea of fun, then look no further! Here's a sampling of the fun we've had so far...

Our first action was a protest at R.M.C. Lonestar in Davenport during a tour of the plant by a convention of cement professionals. We picketed outside the plant to protest the sexual harassment of two local women who worked there.

As a lesbian visibility action, some of us spent a Saturday down at Santa Cruz's Pacific Garden Mall kissing shoppers and people just out for a relaxing stroll, NOT!! Actually, we handed out Hershey's Kisses along with a card that read "you have just been kissed by a lesbian". We had such a great response and so much fun that we decided to do this more often.

We have a church committee of "ladies" who feel their calling is to make a lesbian presence felt at some of our area's more homophobic churches. Five of us attended the Santa Cruz Assembly of God's service on Feb. 6th. We put on our Sunday best, covered ourselves with queer-identified buttons, gave ourselves a group hug (for courage), then walked on in to the sounds of "well, I guess we have to let them in... don't we?" Most of the congregation was pleasant enough, and the Pastor even whipped up a special sermon just for us. This pleased us very much. I'm sure I also speak for the other four, when I say that I got that warm, welcomed feeling most when Pastor Shelley laid unto the congregation "Isn't it wonderful that god allows even the most disgusting people into his house?" Even though we were on our best behavior it was obvious that most of the congregation was more

intimidated by us than we were by them. All in all, this was a very empowering experience.

Our most recent action was in combination with others to hold back Operation Rescue thugs from harassing patients entering and exiting a San Jose women's clinic. My favorite part of this action was serenading those creepy O.R. people with distorted versions of all those Sunday school songs I learned so long ago. We plan to do some clinic defense here in our own area. We've had some reports of harassment of patients at a clinic in Capitola.

We're sponsoring a barbeque on April 16th at Natural Bridges (1:00 pm). We are inviting the entire women's community to come. Bring a dish (potluck) and a donation to help us raise money for future Lesbian Avenger actions, and also to help the efforts of those brave women of Camp Sisterspirit.

Seattle, WA

Yes, the rumors are true... Kurt Cobain may be dead, but the Avengers are alive and kicking in Seattle, WA! We started up in January, and by early February we had our very first action. Early in the morning on a rainy Saturday we dragged ourselves out of bed and down to Tacoma to meet and greet members of the right-wing Christian group Focus on the Family who had come to hold their "Community Impact Seminar" at an area church. The Avenger grrrrls (joined by members of the Seattle group Dykes Against the Right) carried signs and handed out heterosexual questionnaires to inform these clearly out of focus folks and to protest their anti-queer agenda.

For Valentine's Day we decided to do a little something for our own dyke community here in Seattle. So ... we spent our meeting before the big day making the most stylin' and dyke-affirming valentines we could possibly create. On Valentine's day we cruised around Capitol Hill (Seattle's queer neighborhood) and made a bee-line for all the dykey looking women we could find. In addition to the valentines we handed them suckers with tags that read "lesbians taste good (lick, lick)... lick homophobia." We had a great response and even got our first press coverage (a loooovely mug shot in the Seattle Gay News!).

Two weeks later, we held a fabulous kiss-in in front of a local news station. We billed the event as a "Prelude to a Kiss," and smooched up a storm in celebration of the airing of the controversial Lesbian Kiss episode of "Roseanne". Our press release read: "National networks glorify hate, violence and rape, but threaten to censor the broadcast of two women kissing on Roseanne. Lesbian Avengers, therefore, are giving local media an opportunity to broadcast affection between women at our Sunday, Feb. 27 Kiss-in action!!!" Two local network news stations aired us on their nightly news shows, and the SGN printed two action shots as well! Many in the community said that they were thrilled to see our very public display of dyke affection.

March was also a busy month. The very first Seattle Dyke Forum brought dyke groups together to network and being to build coalitions. Specifically, we are working to fight against two ballot initiatives (#608 and #610) similar to the ones recently passed in Colorado and attempted in Oregon in 1992. Sadly, this month the Washington state senate refused to allow discussion of the 17 year old gay rights bill. One Senator, Shirley Winsley (R-Fircrest), stated that she wondered if she would have to wear a bullet proof vest if she voted for the lesbian / gay civil rights bill. Well... Fear not, Shirley

Winsley, the Avengers will protect you!!!! Later that month, in the state capitol of Olympia, we presented Ms. Winsley with a special Avenger-crafted bullet proof vest made from paper mache, chicken wire and a lasagne pan (a fool-proof combo which we think the FBI should, surely, take into consideration... hey, now wouldn't that be a great fundraising technique?).

Our future plans include handing out information at high schools about "what to do if your friend is queer" and helping to organize the dyke march for this year's pride fest in June. Stay tuned for more as this baby dyke chapter of the Avengers grows!

Page 18
Oh So Fine?

SECOND INTERNATIONAL COMMUNIQUE:

The Minneapolis Lesbian Avengers have offered to put together the next communique. Yahoo! We Portland Avengers highly recommend that because there are now close to 40 chapters, submissions be kept to one typed page (max. Please!!). We would love to hear what all the chapters are up to!

Send submissions to:
Lesbian Avengers
c/o GLCAC
310 E. 38th St., Suite 204
Minneapolis, MN 55409

If you can send your submission on a Mac disk, that would be fabulous and would save a lot o' typing. Also, Mpls Avengers encourage you to send along any graphics, photos and visuals.
Deadline for submissions is August 1, 1994.

Portland Avenger seeks works by Dyke playwrights! Having twice directed Holly Hughes' "Lady Dick," Denise is itching for new material and is sure it's out there, and hey, it doesn't have to be published. Send your scripts to:
Denise Morris
c/o Lesbian Avengers
P.O. Box 11544
Portland, OR 97211

It's me! Thanks for joining us all the way to the end. You didn't jump to the last page now, did you! NMK
Photo by Margo Gardiner

Le Guerillas, Gyneocracy & the Burnside Bridge
by Misha Anisoski

If you're going to do it
Do it now
Do me now
Spray paint flays
affronts brick
Your hand
Flexing tight at the wrist
slick, viscous
Armed with graphic
ksss
Seized propaganda from waitress jobs
vivid yellow
No funding but a stamp
Better than no bones
We will not cease to be
mercurial it is only
the way
it is
Water by gutter glistening a tariff
on black engineer boots
The way you stalk easy
down the streets of
only just now
Make my muscles ache in
recompense
Sometimes I have no recourse left
for project H.O.P.E.
but to kiss you
Fuck this poverty of compromise
struggle, dance, fuck
Kid in park says
"take your cape off"
But the women are putting
their capes on

(Project H.O.P.E. is a new strategy adopted by the OCA in Oregon since their statewide anti-"gay" initiative was defeated. To prove their mission is not out of hatred but from a deepfelt love they want to "Help One Person Escape" my lifestyle!)

This communique brought to you with great adoration by the Portland Lesbian Avengers. How do you like the First International Communique? Send us a love note at our new P.O. Box:

Lesbian Avengers
P.O. Box 11544
Portland, OR 97211

BONUS CONTENT

An Incomplete History of LACROP
(The Lesbian Avengers' Civil Rights Organizing Project)

by Kelly Cogswell

The Lesbian Avengers again broke new ground with LACROP. This grassroots organizing project was particularly notable for dumping the top-down organizing model of most organizations, and for encouraging activists to be entirely out, tactics which resulted in its incredible success in Idaho.

CUTTING THEIR TEETH IN MAINE

In the fall of 1993, the Christian Right was attacking Lewiston, Maine's anti-discrimination ordinance and a group of New York Lesbian Avengers headed north to work with local lesbian and gay activists. Most of these Avengers had already had experience in political organizing against the Christian Right, but organizing in a small town was a different story.

While it seems self-evident that a large group of activists working together is more powerful than several little groups, one of the Avengers' biggest mistakes was agreeing to support the mainstream campaign.

Coming from outside, it took some time to realize that this mainstream organization was alienating plenty of local queers by asking them to stay in the closet and enforcing a single message in the name of "campaign strategy."

When they finally broke with Equal Protection Lewiston over its support of the closet, they joined forces with independent lesbian and gay activists. It became a kind of apprenticeship.

> "We learned what it meant to coordinate a door-to-door canvassing effort in the town's low-income district; how to pull off a lesbian and gay "roundtable discussion" whose speakers were so powerful that audience members started unexpectedly coming out in front of the TV cameras; and what it felt like to watch previously closeted teachers, diner owners, and teenagers march down the street together for the first time in their lives."
>
> —Intro LACROP's Out Against the Right:
> An Organizing Handbook

Queers lost in Lewiston, and as outsiders, Avengers were assigned plenty of the blame. But it didn't deter them. In fact, their experience with independent activists there inspired them to formally create The Lesbian Avengers Civil Rights Organizing Project (LACROP) as a working group of the New York Lesbian Avengers, starting in January of 1994.

OUT AGAINST THE RIGHT

At the time, anti-gay initiatives were springing up all over the United States. Instead of leaping directly into another project, LACROP spent several months reconsidering their experiences in Maine, researching the Christian Right and upcoming initiatives, writing grants, organizing fundraisers, and trying to figure out the dynamics of the typical statewide battle against initiatives sponsored by the Christian Right.

While their conclusions were drawn from their work organizing in the early '90's, they could just as well have been based on the failed campaign in California in 2008 against Proposition 8 which banned same-sex marriage.

In each case there was one unified state-wide campaign which had almost all the money and resources available in that state. These state-wide campaigns often shared a mainstream political vision which did not include or even permit any other kinds of organizing. We found that there were plenty of dykes wanting to do out, visible grassroots organizing, but they had no support. Many saw their only options as:

1. to work within the tightly controlled framework of the mainstream campaigns (one state-wide campaign actually required volunteers to sign agreements about what they would and wouldn't say and do during the campaign),

 or

2. to try to work on their own without the benefit of any of the resources, money, research materials, skills, and support systems that were provided by national mainstream lesbian and gay individuals and organizations.

Most importantly, LACROP noticed, that, "These dykes, who wanted to fight the initiatives without giving up their political style or independence, were under siege twice: once by the Christian Right, which deliberately chose to target regions where queers were isolated and had relatively small support systems, and again by the mainstream campaigns, which wanted to control the strategy for everyone and were not willing to share what scarce resources there were."

The question then became how to empower local lesbians and gay men whose aim wasn't just defeating one anti-gay initiative, but creating community with longer-range goals of social change and liberation.

Before long, they had a chance to find out. In 1993-94, rural, conservative Idaho was largely lacking in progressive networks. When the Idaho Citizens' Alliance put an anti-gay measure on the ballot banning everything from anti-discrimination ordinances to queer books in the library, it seemed a slam dunk for the Christian Right. And almost was.

Local queers responded in two ways. The No on 1 Coalition, a loose association of LGBT groups centered in the capital city of Boise, did what queers so often do. They hired a full-time staff and called on the Human Rights Campaign Fund, Gay and Lesbian Americans, and the National Gay and Lesbian Task Force.

These national organizations bankrolled and centralized the campaign, instituting "message control" whereby the executive committee carefully controlled who could speak to the press, or send letters and articles. Arms were twisted to get local groups to comply. And like the 2008 "No on 8" campaign, queers were shoved in the closet and the door locked after them. Television ads avoided the words, "gay" and "lesbian," and focused instead on messages denouncing government interference in private lives.

That was in the southern part of the state.

In the more rural, northern part, a tiny local chapter of Lesbian Avengers in Palouse decided Idaho needed rather different tactics. They called the Lesbian Avenger Civil Rights Organizing Project (LACROP) in New York to come help, and eight full-time and ten part-time workers arrived, headed up by native Idahoan, Sara Pursley.

After their experiences in Maine, and months of planning, and with substantial financial and tactical support from the New York Avengers, LACROP did almost everything

in reverse. Local lesbians and gay men were put front and center, encouraged to set their own priorities, come out in their communities and share power as widely as possible. Together, they organized speak-outs and kiss-ins. Some even went door-to-door to talk about their lives. Nobody was censored. And getting your voice heard and your life validated made it worth the risks of violence, vandalism, and fear. Queers made connections with each other, forged a place in their communities, and by the way, won a bunch of votes.

The northern, rural region where the out and proud LACROP was active defeated Proposition 1 by a significant margin. The centralized, closeted efforts in the more urban and progressive area around Boise only narrowly defeated the measure, with the rest of the nearby counties voting overwhelmingly "yes" to adopt Proposition 1. The extra votes in the LACROP region made the difference, along with Mormons who actually voted "no" because of bashing from the Christian Right.

Perhaps more importantly, this "out" campaign allowed LGBT Idahoans to take center stage in the battle, creating an LGBT community and infrastructure, laying the groundwork for continued social change.

Keep reading for excerpts from LACROP's *Out Against the Right: An Organizing Handbook.* Here you'll discover the benefits and pitfalls of coalition work, tips on centering lesbians, notes on the importance of long-term, strategic thinking, and more.

Tips from
Out Against the Right:
An Organizing Handbook

The basic conclusions of LACROP after mistakes in Maine, and incredible success in Idaho. Drawn from the Lesbian Avenger' Civil Rights Organizing Project—*Out Against the Right: An Organizing Handbook.*

BASIC PREMISES

1. It is vital to organize as OUT LESBIANS when working both within our own communities and against the Christian Right.

The Christian Right has been very successful in using the closet against us. When their messages are about "the homosexual agenda" and we respond with de-gayed messages like "no government intervention in private lives" or "no censorship", we look not only ashamed, but dishonest. Voters are unlikely to stand up for the rights of an invisible community.

Beyond initiative elections, being out is a must for organizing in our own communities. One out lesbian can inspire countless other lesbians. Five out lesbians can have a successful direct action. Ten out lesbians can effectively door-to-door canvass an entire town about an issue. A million out lesbians ... well, let's not get ahead of ourselves.

In addition to being out, we place a lot of importance on working with a core group of dykes, since lesbians have traditionally been excluded or disempowered in lesbian/gay struggles. We realize that many people, especially in rural areas,

will be working in a mixed core group, but we always look for a focus on lesbian empowerment and lesbian visibility. We are a lesbian group with a commitment to lesbian leadership in all our projects and actions. That's our bottom line.

2. People are different. We are most effective when we work with people who share our basic ethical and political perspective, instead of trying to pressure everyone into a single strategy or single organization.

We believe that there are hundreds of ways of organizing and just as many approaches to fighting the Right. We don't require our allies to agree with us on every subject, but to get things accomplished, it makes sense for us to focus our support on working with people who are committed to doing out, visible, grassroots organizing. This is the kind of work we believe in and through which we can be most helpful. We do not work with groups that we fundamentally disagree with.

All lesbians, gay men, and straight progressives simply do not need to work in the same campaign organization. If people disagree strongly about strategy, they should work in different groups. It is a waste of time, not to mention emotional energy, to try and argue everyone into consensus; what inevitably happens is that some people—usually those without resources and/or confidence—simply give up and others end up determining the strategy.

3. We must challenge racism and classism concretely—in our organizing efforts.

The Christian Right targets low-income communities, rural areas, and communities of color. They capitalize on economic depression, and on social and political disenfranchisement by using propaganda which says that lesbians and gay men constitute a politically and economically

powerful interest group seeking "special rights". They suggest that civil rights are a finite set of privileges—if (presumably white, middle-class) gays and lesbians get their piece of the pie, then (presumably straight) people of color or low-income people will not get theirs. In this worldview, there are no lesbians and gay men of color. In addition, it implies that "rights" come in a fixed quantity—there are only so many to go around, so we should all fight over them.

Many traditional campaign groups have been unable or unwilling to confront this strategy. They have virtually ignored low-income and rural regions and communities of color based on the assumption that these communities are not valuable voting blocks. They're too small, too dispersed, too homophobic, or they're probably not registered or willing to register to vote, anyway. Dykes and fags who live in these areas are ignored. Addressing and challenging the racism and classism of the Christian Right is one way to dispel the "special rights" rhetoric for the smoke screen it is. Remember, the Christian Right is banking on the old divide and conquer strategy. We can't afford to buy into it.

This also means that we do not "whitewash" our communities. Some campaigns encourage only certain, "respectable," lesbian and gay people to come out to the public. As we wrote in our 1994 "Out Against the Right" Manifesto, "We will not accept superficial legal rights for some lesbians and gay men at the expense of real human rights for all of us. Butch, femme, and androgynous dykes, lesbians and gay men of color, drag queens, lesbian and gay youth, transsexuals, people with AIDS, lesbians and gays with disabilities, and rural lesbians and gay men will not be sacrificed in the name of 'campaign strategy'."

4. There is more than one message.

Campaigns can and have been won by lots of different lesbians doing lots of different things with lots of different messages. If a dyke has a message that's important to her (about how hard it was to come out to her family, how she lost her job, what it's like to be a logger and a lesbian, how as a lesbian librarian she can really talk about the evils of censorship ... whatever), she needs to be able to express that message.

Highly centralized, volunteerist campaigns ask that queers stick to the message they've come up with by paying lots of money to pollsters. They ask that we put off our long-term goals of mobilizing and strengthening our community in favor of the short-term objective of winning the vote. Silencing members of our own community who wish to express what the campaign means to them as people who will have to live with its results is unfair and also ineffective.

Lesbians in local communities can and should organize their own campaigns and/or actions in whatever ways they choose—even though bigger, more traditional, better-funded groups often insist that their way is the only way, and use tired rhetoric about "experts" and "professionals" to pressure everyone else into agreeing with them. In fact, anyone can go door to door, plan an action, have a rally, or distribute flyers in a town.

5. It is crucial that lesbians around the country share resources, experiences and support.

The forces against us are huge, well-organized and long-term. We cannot expect to take them on alone.

The Christian Right has a long-term planning strategy and we need one too. Whether we win or lose a vote we need to make sure there will be an organized community afterwards, one that will develop sustainable structures and groups who will be there to fight for our future survival. An anti-lesbian-and-gay initiative campaign is a good situation in which to start building, though obviously not one we would choose, because there is intense momentum gained in a short concentrated amount of time. How can you hold on to this momentum?

Thinking about "after the vote" has to begin early—as early as thinking about "starting a campaign." Some strategies lend themselves to ongoing organizing; others do not. Does your movement or group have only one spokesperson, one person who makes all the decisions? What if that person leaves town or gets burned out? That movement or group is probably not going to make it. On the other hand, consider a campaign which has given many activists a point of entry, and has promoted shared ownership of the work. That campaign can evolve into a rich movement, with room for many kinds of ongoing work and shifting leadership.

We try to organize in ways that build momentum and will be sustainable. Some of the ways to accomplish these goals are:

- focusing on action
- sharing skills and information
- sharing ownership and leadership of the work
- keeping track of how we do things, what is successful, and what is not, and

Always, always being visible and recruiting.

But even if you work in all those ways, the success of your group after the campaign is still not guaranteed. We learned painfully, from our experience in Maine, that

if we were organizing in an area in which we didn't live, we couldn't just leave after the vote and simply maintain personal contact with individuals we had met. We had to figure out a way to put closure on the initiative campaign which would give us information about what did and didn't work and also would provide a place for all of the diverse groups which had worked against the initiative to meet and talk about the campaign and the future of organizing in their area.

In the section which follows we talk about what happened in Idaho, both immediately after the vote and during the next year. Some of these were events the New York LACROP group was involved in, including actions immediately after the vote and the "Out After 1" Conference. Other events were described to us by Natalie Shapiro, a founding member of the Moscow Avengers (which later expanded to become the Palouse Avengers) who later founded IRONGAL, the Idaho Rural Outreach Network of Gays and Lesbians, and by Judy Hasselbrouk, a co-founder of the Lewiston Lesbian and Gay Society and who, after the vote, also joined the Palouse Avengers. One NY Avenger moved to Idaho for the following year, and worked on IRONGAL. We've compiled these experiences to give you a picture of what happened after the vote, along with suggestions for what you might do in your area.

THE DAY AFTER THE VOTE

It may seem that once the voting is over and the results are in, your work is done. In reality, it has only just begun. The challenge after the vote is keeping people active, uniting different aspects of the community, and changing your stance from reactive to proactive. Whether you've won or lost, the day following the vote is a key time for an action.

Plan an event to symbolize your strength and endurance, and to inform the Right that although the vote is over you will not lie back down and return to the closet. Use it to acknowledge all kinds of contributions that the community made to your campaign—the hard work, support, and donation of space or resources—and to point out the progress that was made by your project, regardless of the outcome of the vote. And don't forget to gather names.

> **Here's how Judy described the day after in Lewiston, Idaho:** *Election evening in Lewiston, Idaho was spent sewing together a 100 foot wide pink triangle to be placed on the top of "Lewiston Hill," a giant hill that encloses the town and can be seen from every point of the city. It was a non-confrontational action yet it united the Lewiston Lesbian and Gay Society as we struggled to complete the masterpiece before sunrise. It towered on the hill the day after the vote, demonstrating our commitment to continue fighting for our rights and illustrating that our spirit was not diluted.*

The Lewiston action was designed so that it would be meaningful whether or not the vote was won. The same was true of the action planned for Moscow by the Palouse Avengers. On the day that voting was taking place they distributed and wheatpasted a flyer that said:

What are You Doing the Day After Proposition One?

Join the Lesbian Avengers in a Victory March or Protest.

After debating between a protest, a waltz-in/kiss-in at the local downtown square, or fire-eating, they settled on eating fire in a central location. The action was timed to happen just after daytime working hours. The media was invited and were astonished, along with many other onlookers, as Avengers extinguished the radical right hatred they had seen and heard over the past few months by eating the fire that symbolized their fury. And, although we won the vote the signs spoke to the

future. For example, one sign addressed the frighteningly close vote: "51% is not enough." The message that we had triumphed was clear cut, it was clear too that we could not become complacent.

If the results of the vote are close, the outcome will not be known until the following morning. Planning an action that you can use regardless of the results means that you won't have to alter your action plans at the last minute. You will also have plenty of time to alert the media. And, doing an immediate action the day after that symbolizes your strength—win or lose—will contribute to your momentum for a long time to come.

A FEW WEEKS AFTER THE VOTE

The vote is over, you've slept for a couple of days, seen a couple of movies and begun to relax, but the Right will not be wasting any time planning next year's initiative so neither can you. Keep in mind that many people in our communities will be burned out. They have been living and breathing this campaign day and night for the last few months. On the other hand, many will still be flying high on the adrenaline, rushing to take a proactive stance to ward off any future attempts by the right to legalize homophobia.

This is a good time to reflect on what you have learned, and how the political process has changed you, as an individual, and how these same events have impacted your larger communities. Not everyone will respond to what has happened in the same way that you do. Groups fighting anti-lesbian-and-gay initiatives tend to have the same end goal but all want to take different roads to get there. This is a useful time to bring together the many groups and individuals that worked side by side so that you can relate positively now that the vote is over.

During the campaign we made alliances with people throughout northern Idaho; the stage was set for long-term organizing. Proposition 1, the anti-lesbian-and-gay initiative, was a short-term issue that drew people together. How would people maintain these connections for a long-term movement? What issues were important and what strategies would we need? To help begin answering these questions, LACROP organized and coordinated a conference to be held two weeks after the vote, called "Out After 1."

We tried to organize the conference so that the widest diversity of people could come and would come.

Natalie thought: *The conference was unique in that it was free. Most conferences cost money, which precludes poor people from attending, thus ensuring that only those with money have access to information and empowerment. In addition, lunch was free and we offered to reimburse people for transportation costs. To cover expenses we wrote a grant (and got a local restaurant to donate food). To reach as many people as possible we mailed invitations and a conference schedule to all the individuals and groups we had met during the Proposition 1 campaign. One thing we did not do that we should have was place ads in all local newspapers and put up flyers in all rural communities.*

The conference had four workshops:

1: Looking Back/Moving Forward: What impact did the struggle against Prop. 1 have on our lives and communities? What obstacles and opportunities do we face now? Speakers included grassroots northern Idaho groups that helped in the fight against Prop. 1.

2: Responding to violence in Northern Idaho: How and why is violence used against gay men and lesbians? How can we build long-term

support structures for each other in the face of such violence? Speakers from the Idaho and Oregon Anti-Violence Projects were invited.

3: Rural Organizing in Northern Idaho: How do rural lesbians and gay men find each other? How can we build long-term structures to organize for lesbian and gay rights in rural communities? The Oregon Rural Organizing Project and those in Idaho interested in rural organizing presented.

4: The Lesbian Avengers: Using direct action to fight for lesbian visibility and survival.

Natalie describes what it was like: *The conference was emotionally moving as participants reflected on the last three months. The importance of queer visibility in fighting anti-gay initiatives came up again and again. During the anti-violence panel, people discussed anti-gay incidents in their lives, and what resources are out there to fight hate crimes. During the rural organizing workshop we discussed how to approach rural communities. Overwhelmingly, people wanted to build coalitions between the various groups in our communities, both within the queer community and between the queer and straight communities. How do we do that? We discussed finding an issue that would tie us together, such as democracy at risk.*

Natalie detailed what she considered to be the four goals that emerged from the conference: *building coalitions within the queer community, starting an anti-violence project in northern Idaho, starting a rural organizing project throughout Idaho, and continuing and strengthening the three grassroots groups in the area: the Palouse Avengers, the Lewiston Lesbian and Gay Society, and PLUS (People Like Us). Everyone agreed that lesbians and gay men had to continue being visible and working to make northern Idaho a place where they could live openly and proudly.*

THE MONTHS THAT HAVE FOLLOWED THE VOTE

In the months that have followed the vote, some ideas and groups have survived; others haven't. The attempt at a lesbian/gay coalition fell apart, and the anti-violence project didn't seem to garner any interest. On the other hand, the Rural Organizing Network is alive and, despite some fits and starts, the Palouse Avengers, The Lewiston Lesbian and Gay Society and PLUS are still going strong.

Kelly Cogswell is an award-winning journalist, author of the 2014 memoir, Eating Fire: My Life as a Lesbian Avenger, and founder of the Lesbian Avenger Documentary Project.

YOUR NOTES

YOUR NOTES

ISBN 978-1-7361558-0-6

90000